Yeshiva University Museum

Echoes in the Silence:

DRAWINGS BY BENJAMIN LEVY

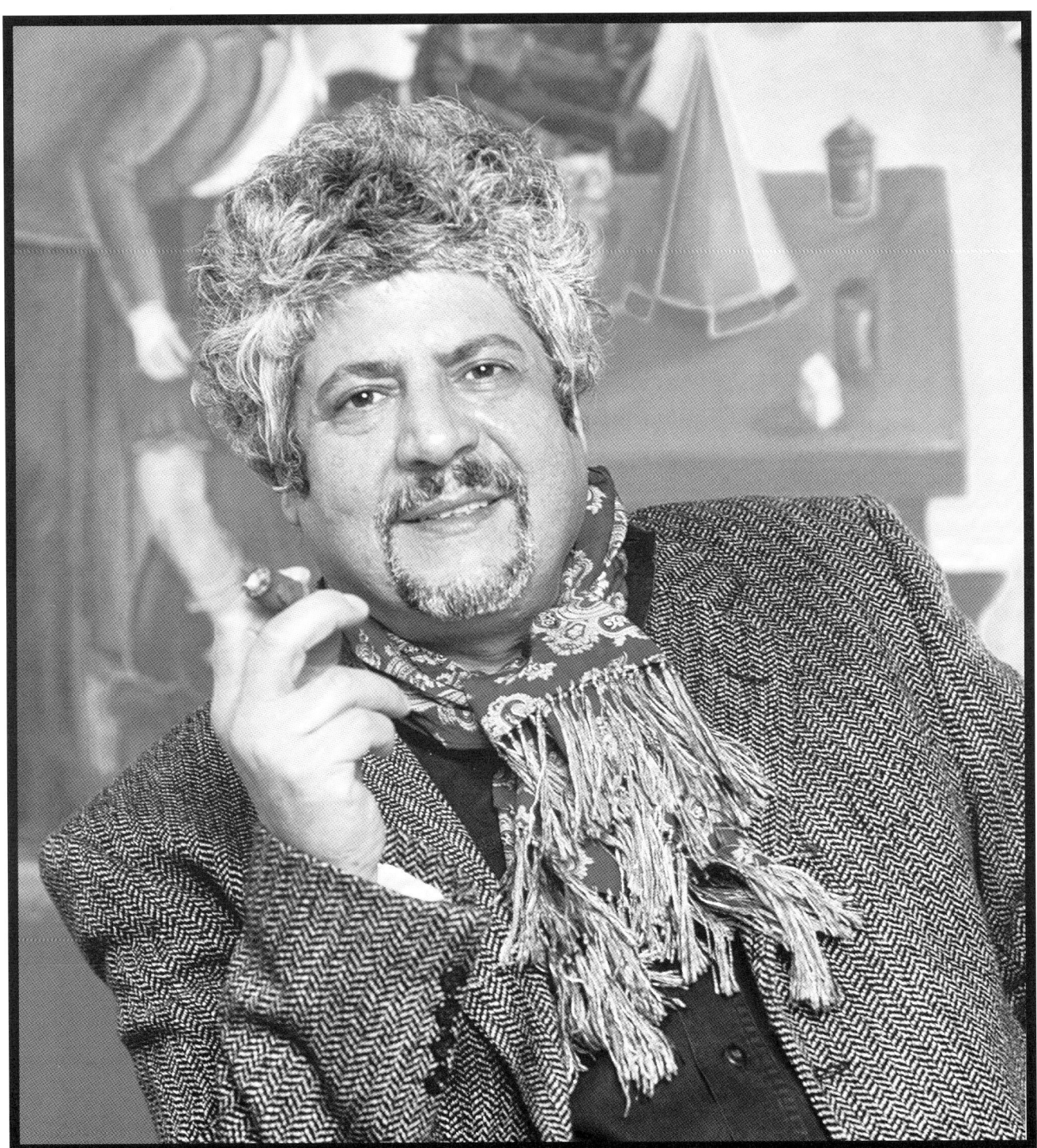

Echoes in the Silence:

DRAWINGS BY BENJAMIN LEVY

by Daniel Piersol

New Orleans Museum of Art
1998

2,500 copies of this catalog were published in conjunction with the exhibition *Echoes in the Silence: Drawings by Benjamin Levy*, organized by the New Orleans Museum of Art.

Library of Congress Catalog Card Number: 98-66147
ISBN 0-89494-067-8 hardcover
ISBN 0-89494-066-X softcover

Designed by Bridget McDowell,
New Orleans Museum of Art
Photography by Will Drescher,
New Orleans Museum of Art
Printing by Metairie Printing,
Kenner, Louisiana

Cover: *Balancing Act (Woman)*,
catalog 5

Frontispiece: Benjamin Levy,
1998, Photo by Robert Blosser

Contents

Acknowledgments

The New Orleans Museum of Art is proud to present *Echoes in the Silence: Drawings by Benjamin Levy*, an exhibition which showcases this artist's beautiful and eccentric images. This presentation underscores NOMA's continuing commitment to seek out and present to our visitors works on paper by the finest contemporary artists, and follows recent showings such as *Liquid Vistas: Watercolors by Margaret Pace Willson; Transparent Motives: Prints from Glass Plates; Walter Rutkowski Drawings;* and *Hockney to Hodgkin: British Master Prints, 1960-1980.*

Benjamin Levy's lively, whimsical, witty and decidedly idiosyncratic art is immediately inviting and approachable. No ominous forces loom in the background of his images, and neither anger nor violence appears to dampen our curiosity and interest. But Levy's art does have an underlying serious side, rooted in the history and his love of family and his corresponding compassion for all humankind. With the tenderness and understanding of an indulgent parent he examines and reveals our passions, weaknesses, triumphs and failures, and allows us to draw our own conclusions.

Levy works on paper habitually, whether quickly limning in graphite a solitary figure or fashioning over many days a complex interior with gouache and watercolor. The artist's drawings—intuitive, spontaneous and searching—are the most immediate and direct response to his innate creativity. Because they are so often the wellspring for the recurring array of personages and symbols he employs, these drawings also provide the key to interpreting and comprehending his paintings and sculpture. But these superb visions, which certainly stand on their own in the artist's ouevre, must be viewed and appreciated for their intrinsic beauty and merit.

This exhibition is the result of the efforts and contributions of many people, all of whom are deserving of recognition. Curator of Prints and Drawings Daniel Piersol worked closely with the artist, selected the works for the exhibition and wrote the perceptive catalog essay. Other members of the Museum staff provided valuable service: photographer Will Drescher produced beautiful transparencies of the drawings; curatorial secretary Gerri Delone carefully prepared texts and checklists; librarian Carl Penny kindly proofread the manuscripts with his customary efficiency and thoroughness; the commitment and skills of Publications Coordinator Wanda O'Shello and Graphics Coordinator Bridget McDowell have resulted in our handsome catalog. Thanks is due also to Hanna Levy for her tireless assistance in updating records for this publication and to Amalia Peña for recording the information on disk.

Finally, we are all indebted to the artist, Benjamin Levy, not only for his patient and unhesitating cooperation in planning this exhibition, but also for creating and sharing with us the extraordinarily imaginative and beautiful drawings which comprise it. The New Orleans Museum of Art is indeed honored to present these "echoes" of the artist's soul.

E. John Bullard
The Montine McDaniel Freeman Director

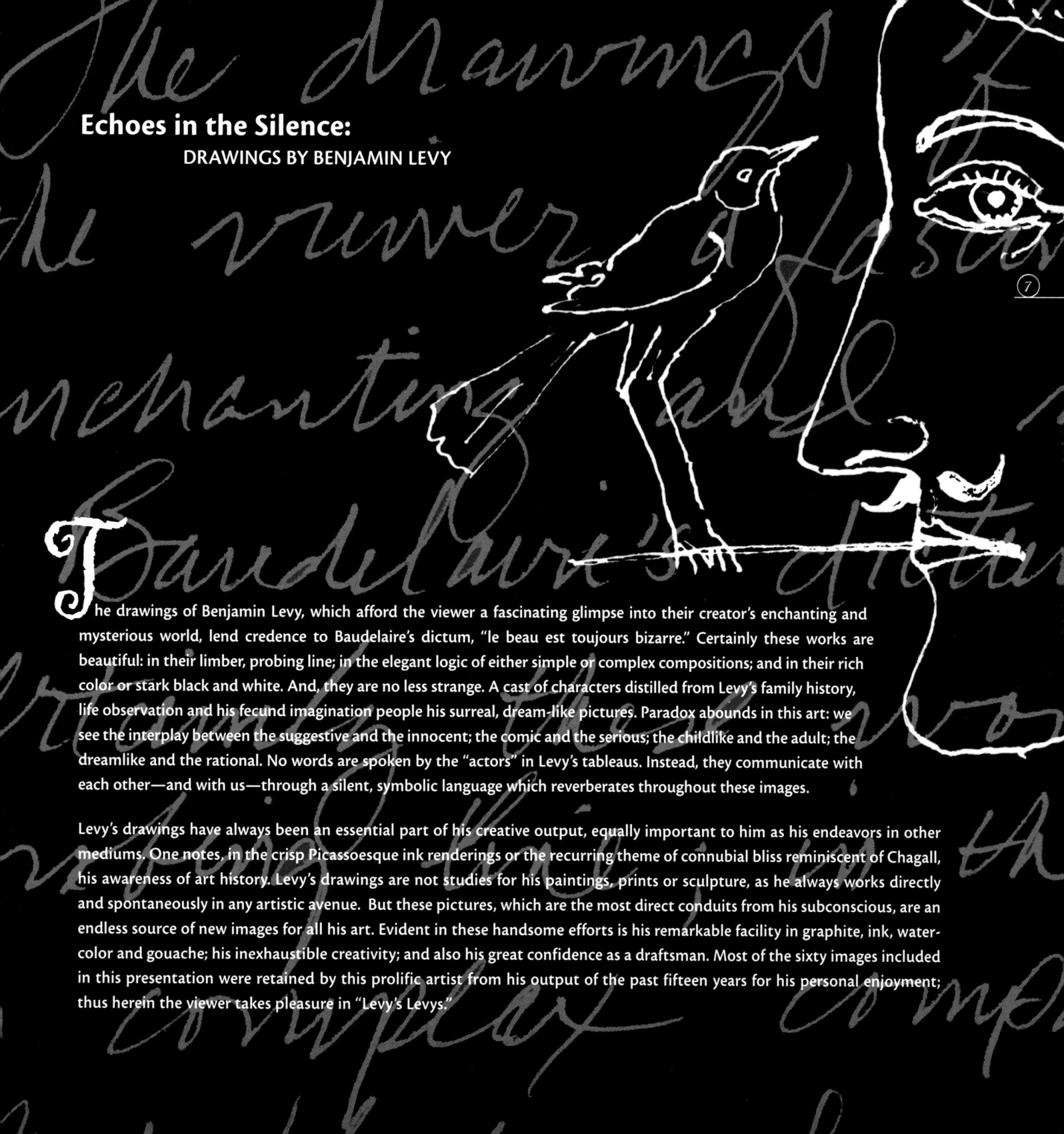

Echoes in the Silence:
DRAWINGS BY BENJAMIN LEVY

The drawings of Benjamin Levy, which afford the viewer a fascinating glimpse into their creator's enchanting and mysterious world, lend credence to Baudelaire's dictum, "le beau est toujours bizarre." Certainly these works are beautiful: in their limber, probing line; in the elegant logic of either simple or complex compositions; and in their rich color or stark black and white. And, they are no less strange. A cast of characters distilled from Levy's family history, life observation and his fecund imagination people his surreal, dream-like pictures. Paradox abounds in this art: we see the interplay between the suggestive and the innocent; the comic and the serious; the childlike and the adult; the dreamlike and the rational. No words are spoken by the "actors" in Levy's tableaus. Instead, they communicate with each other—and with us—through a silent, symbolic language which reverberates throughout these images.

Levy's drawings have always been an essential part of his creative output, equally important to him as his endeavors in other mediums. One notes, in the crisp Picassoesque ink renderings or the recurring theme of connubial bliss reminiscent of Chagall, his awareness of art history. Levy's drawings are not studies for his paintings, prints or sculpture, as he always works directly and spontaneously in any artistic avenue. But these pictures, which are the most direct conduits from his subconscious, are an endless source of new images for all his art. Evident in these handsome efforts is his remarkable facility in graphite, ink, watercolor and gouache; his inexhaustible creativity; and also his great confidence as a draftsman. Most of the sixty images included in this presentation were retained by this prolific artist from his output of the past fifteen years for his personal enjoyment; thus herein the viewer takes pleasure in "Levy's Levys."

Much of Levy's narrative art is rooted in mythic family tales and remembrances. Near the beginning of this century the artist's grandfather died in Yemen. His survivors, including Benjamin's father, Ovadiah, set out on the long and arduous trek across the desert to the spiritual Jewish homeland in Palestine. Ovadiah's mother and infant brother succumbed along the way, leaving the teenage lad and his even younger sister to enter Jaffa alone. Hardship continued to visit Ovadiah Levy as an adult, as his wife and their twin offspring died. But he remarried at the age of forty to Batsheva, a fourteen-year-old orphan whose Sephardic Jewish parents had migrated from Turkey and Yugoslavia, and they raised eleven children, including Benjamin. To shelter his family, Ovadiah built one of the first homes in Tel Aviv, near the beach in what would become the Yemenite quarter. He supported his brood as a peddler of nuts, seeds and candy, as well as birds and fish (which appear frequently in Benjamin's art, as do many other creatures).

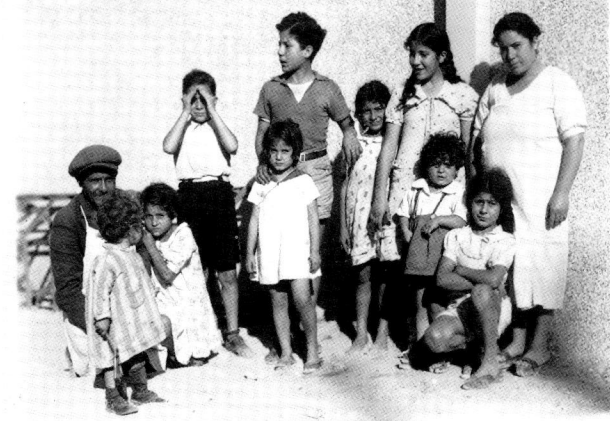

Figure 1

The family's happiness is reflected in Benjamin's fond memories of his youth. His creative talent was noted during childhood and was nurtured by sympathetic, supportive teachers. As a young man, Levy was employed for a time as a photoengraver in Haifa, and he later worked while studying art in Paris. After a period when he traveled extensively, he returned to Tel Aviv. There Benjamin not only set up a studio at his parents' home but also married Hanna Vroman, a native Israeli of Dutch Ashkenazi parentage. But in 1965 the couple abandoned their comfortable life in their homeland for New York City, where Benjamin has since garnered great acclaim and success. They and their four children (now striking young adults) have for years summered in Tel Aviv and spent the winters in New York. Levy maintains studios in the aforementioned cities and also in an artists' colony in Haifa. Now, as before, family is a central focus in the artist's life and continues to have lasting effect upon his art.

Since its inception in 1839, photography has influenced the art of many who have worked in the traditional mediums of drawing, painting, printmaking and sculpture. Eminent creators such as Edgar Degas, Charles Sheeler or Pablo Picasso are but a few who have drawn upon photography as a source or reference at various times during their careers. Similarly, a stack of old family photographs discovered at his sister's home more than thirty years ago has proven to be a most important source of inspiration for Benjamin Levy. Enamored of the medium's ability to capture his loved ones for posterity, Ovadiah Levy drew together his kindred whenever an itinerant cameraman passed through. These images, many of which predate the artist's birth in 1940, function as much more than mere *aides de memoire*; rather, they serve as points of departure for Levy's boundless imagination, and they also provide

insights into his art. For example, an informal, open-air group portrait from 1939 (fig. 1) includes not only Benjamin's parents and eight siblings but also a neighborhood boy who was asked to stand in for an absent brother (yielding to local superstition). The lad's shielding of his face to cover his extrafamilial identity lends a certain quirkiness to an already amateurish document. Clearly based upon this image is *My Family on the Beach* (1990, cat. 26), a restrained, nostalgic interpretation which transports parents and children to a time and place for frolic far away from the actual setting of the photograph. *Family Picture* (1983, cat. 10) employs a silhouetted human form, probably suggested by the aforementioned anonymous child, to allude to a missing loved one. These lyrical, photographically inspired drawings are like a child's blissful remembrances; within each, time is suspended and reality merges with fantasy. *My Father, My Aunt and My Uncle* (1983, cat. 14), derived from a formal studio portrait (fig. 2), goes further afield. In the latter the photographer's camera has faithfully recorded the sober gaze and proper bearing of the sitters who stiffly awaited the flash of light. But in Levy's fanciful concoction the atelier is transformed into an airy playroom where the inhabitants, now in the company of a cat and an ostrich, amuse themselves without concern.

The inherent theatrical quality of much of Levy's art also owes, in part, to the influence of these studio photographs. The "actors," attired in their distinctive ethnic costumes, were coached by the "director" who artfully posed them on a "stage" replete with various props and an illusionistic painted backdrop. The "scene," of course, is now frozen in time. Interiors derived from remembrances of his parents' home also function as "sets" for many Levy drawings. In such a home, the artist recalls, a simple fabric flap—behind which the inhabitants could hide whatever they wished—served more as a blind than barrier between rooms. While a similar device appears in several drawings, its most interesting use may be in *Mystery Guests* (1986, cat. 20). Therein, a curious structure resembling a curtained stage encloses all the *dramatis personae* except for one who attends "in the wings." By separating the "players" who appear to be awaiting a cue, the drapery helps to establish a sense of enigma and anticipation.

In many drawings Levy recounts family legends or weaves his parents' instructive parables into his art. In the romantic tale of Batsheva and Ovadiah, for instance, the artist's father recalled that on their wedding day his bride blushed so brightly that he felt she was arriving to the ceremony naked. This charming anecdote, an amalgam of the sensual and the chaste, is the basis for drawings such as *Temptation* (1995, cat. 46) and *The Beautiful Couple* (1997, cat. 59). *Sharon and Ofer's Wedding* (no date, cat. 4), which is based upon a recent family event, reflects the artist's ability to suggest a childlike view of the world even as he makes adult observations. Out-of-scale musicians are at the center of attention, their frenetic playing suggested by the implied movement of the performers' cubistic

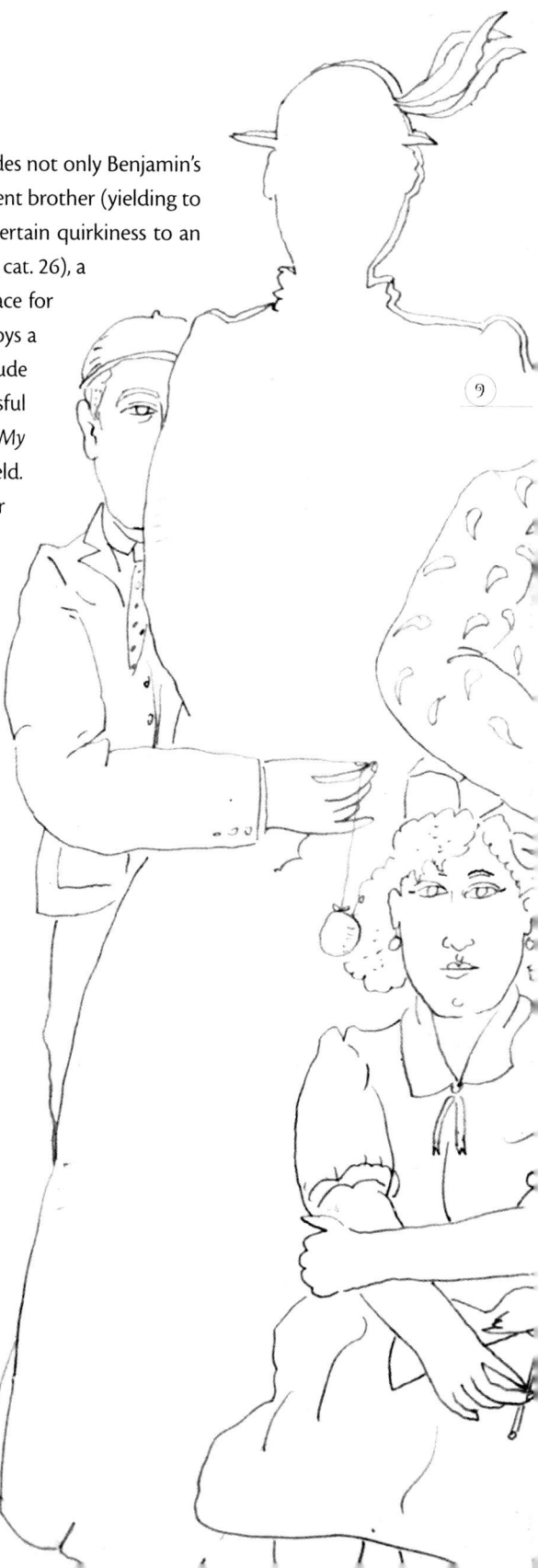

9

faceted faces and the tangle of arms. The musicians' multiple eyes harken to the magical fish Ovadiah Levy described to his young son, fish whose double lenses allowed them to see above and below the water simultaneously. Perhaps the musicians, endowed like the fish with greater acuity, can see the future of the newlyweds whose world is now as circumscribed by their marriage as their appearance is by the mirror.

Levy's art, however, is not concerned solely with kin. The artist has long visited favorite themes through the use of imaginary characters or "types" drawn from personal observation. A recurrent topic in Levy's art is the nature of communication, especially between the sexes. A most subtle and silent form of exchange is non-verbal language— gesture, glance and posture—and Levy reveals to us many adult guises, sometimes humorously but always perceptively. The shifty-eyed, unnerving visage we encounter in *Balancing Act—Man* (1995, cat. 43), for instance, compels us to withhold our trust, while the intent stare of the beauty in *Balancing Act—Woman* (no date, cat. 5) curiously beckons even as it keeps us at a distance. The tiny ball, so precariously balanced near each figure's mouth, is a symbol of the capricious nature of human affairs. Whom do we trust? How can we be certain? False faces appear as reminders of the human need and capacity for role-playing. In *Double Mouth* (1996, cat. 50) a male figure contemplates us sidelong from behind his mask. Do the two mouths suggest a duplicitous nature, or is the mysterious gentleman merely voluble? What message will he send via the waiting messenger bird? *Who Am I?* (1995, cat. 42) presents a woman peering from behind an ill-fitting man's mask, perhaps a likeness of her

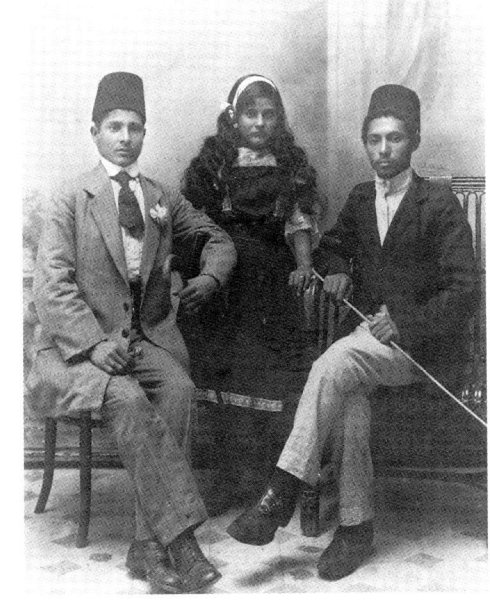

Figure 2

husband or lover. Her fluttering, double-eyed gaze is fixed unabashedly on her audience, and her sexual interest is further announced in Levy's emphatic treatment of her melon-like breasts and in the lurid scarlet background. More direct is the woman in dishabille depicted in *My Little Angel* (1996, catalog 52), who brazenly displays herself. Standing before us with her hip thrust provocatively forward and her eyes lolling languidly behind heavy lids, she sends the viewer not so much a message as an invitation.

In addition to his examination of corporeal modes of communication, Levy also evinces his interest in the venerable epistolary tradition. The love letter, long emblematic of flourishing passion, is the basis for *Anonymous Letter* (1997, cat. 60). This image appears almost as an episode from a romance novel, as a bare-breasted beauty moistens the seal on a mysterious missive. An empty envelope serves not only as the support for *Birdland* (1993, cat. 36) but also as a potent symbol of unrequited love. The solitary figure who dolefully returns our glance sits before a seemingly endless seascape, but the edges of the envelope define the narrow limits of his world and indicate his hopeless situation. Only the flitting birds, it would seem, are free. The feather quill and journal in *What's Awaiting Us?* (1996, cat. 55) hint at confessional narrative (and who among us is not curious about the jottings in

another's diary?). The unsteady spheres, the scampering mice and the death's head which sits akimbo atop the writing desk reveal the author's preoccupation and serve as reminders of both life's uncertainties and its inevitable end.

No doubt recalling his brother Daniel's deafness, Levy also ponders the failure of communication, or isolation. In *My Red Tie* (no date, cat. 2), *In Uniform* (no date, cat. 3) or *The Observer* (no date, cat. 1) he employs found, shaped supports to render the comically attenuated men who remind us that we are confined to and ultimately conform to our positions or roles. *The Young Soldier* (1993, cat. 37) humorously recalls Oz's hapless Tin Man. Trapped in an absurd, tightly-fitted military tunic and standing in spare, cell-like surroundings, this woebegone warrior is a study in detachment. The key protruding from an ear on his rectilinear head, as if from a lock, signals his remove, while the plume of smoke pouring from the vent of his pot-helmet bespeaks his pent-up frustration. In images such as *My Family on the Balcony* (1983, cat. 13) Levy fits male figures with archaic miniature hearing-horns to accentuate their isolation. The wittily ironic *Let Me Hear You Sing* (1994, cat. 39), also created on a discarded item, goes even further by imprisoning an ostensibly deaf vocalist literally and figuratively within a box of silence.

A number of the drawings clearly plumb the psyche and divulge the nature of dreams. Levy's free association of images drawn from both conscious and subconscious sources leads to bizarre tableaus such as *Untitled* (1993, cat. 35) or *The Visit* (1991, cat. 32). In the latter, elements of the recumbent dreamer's (hence Levy's) reverie surface; among them, the hunchbacked figures (Ovadiah, who carried his sister across the desert on his back); the zoomorphic nude with the cock's head (Batsheva, who dispensed wisdom with counsel such as "Observe the chicken: after every drink of water it raises its head to thank God"); the centaur-like creature who connotes our instinctual or unreasoned behaviors; and the cleric whose yo-yo refers to the tenuousness of human existence. The various hats— yarmulke, fez, or fedora—not only lend a certain identity to their wearers, but also serve as reminders of the many lands, cultures, and journeys which are woven into the fabric of Levy's family and his art.

Through the wizardry of his drawings, Benjamin Levy whisks us into the mystical locus of his imagination. In this strange and paradoxical world, figures from the artist's life and subconscious meet at the crossroads of reality and dreams. Like the director of some otherwordly mime theater, Levy with pen and brush sets his stage and positions his players upon it. Magically, these characters speak to each other and to us with the wordless dialogue which echoes in the silence.

Daniel Piersol
The Doris Zemurray Stone Curator of Prints and Drawings

The author wishes to acknowledge important sources for this essay: La Familia: Memories & Reflections, (exhibition catalog, Ori Z. Soltes, Washington, D.C., B'nai B'rith Klutznick National Jewish Museum, May-July, 1993); Benjamin Levy: Recent Paintings and Works on Paper (exhibition catalog, Nahan Galleries, New Orleans, Louisiana). Additional information was derived from interviews with the artist conducted on January 22 and 23, 1998, and February 18, 1998.

10. *Family Picture*, 1983
 graphite on paper
 15 x 19 inches

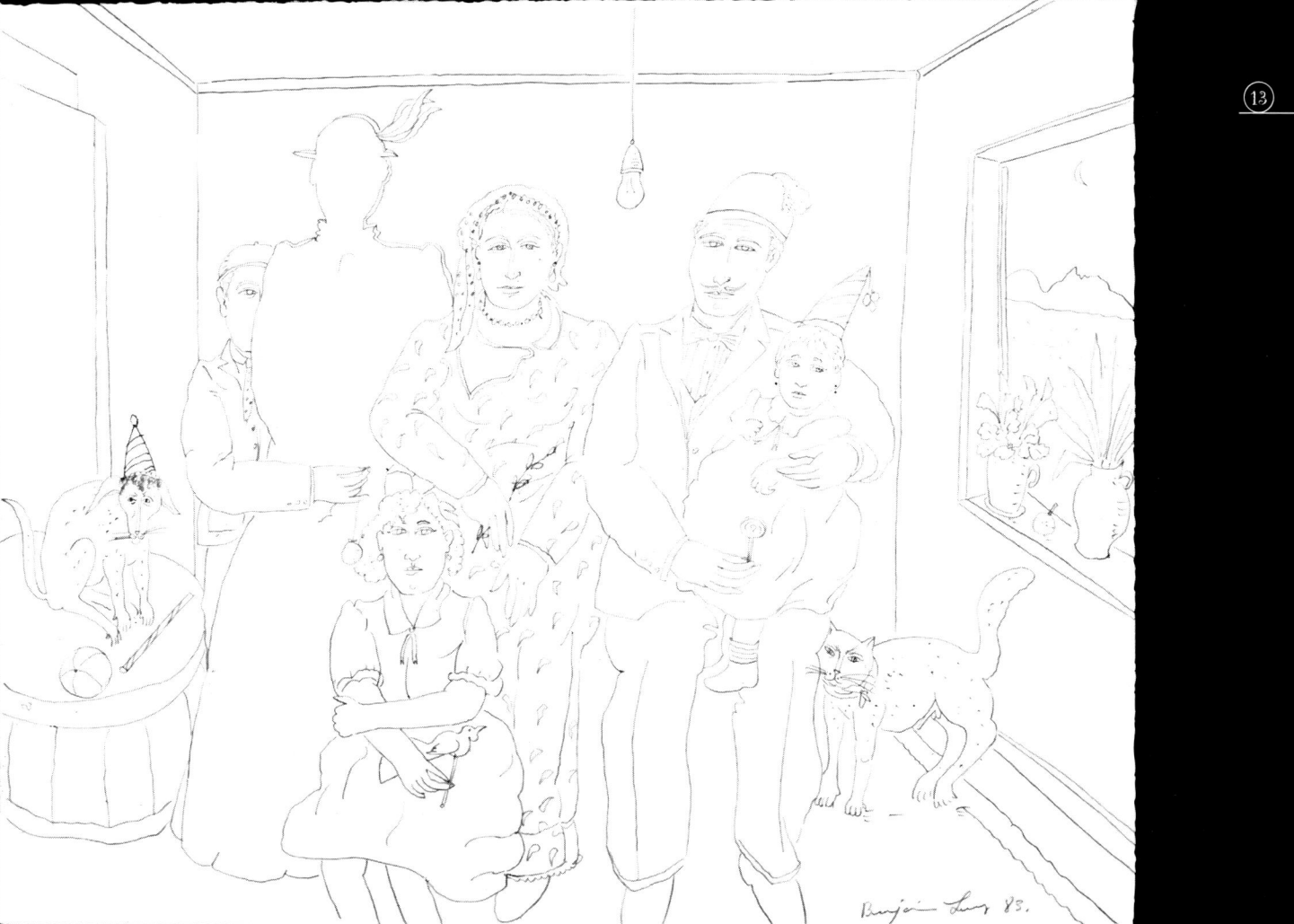

11.	*Sisters*, 1983
	ink on paper
	15 x 19 inches

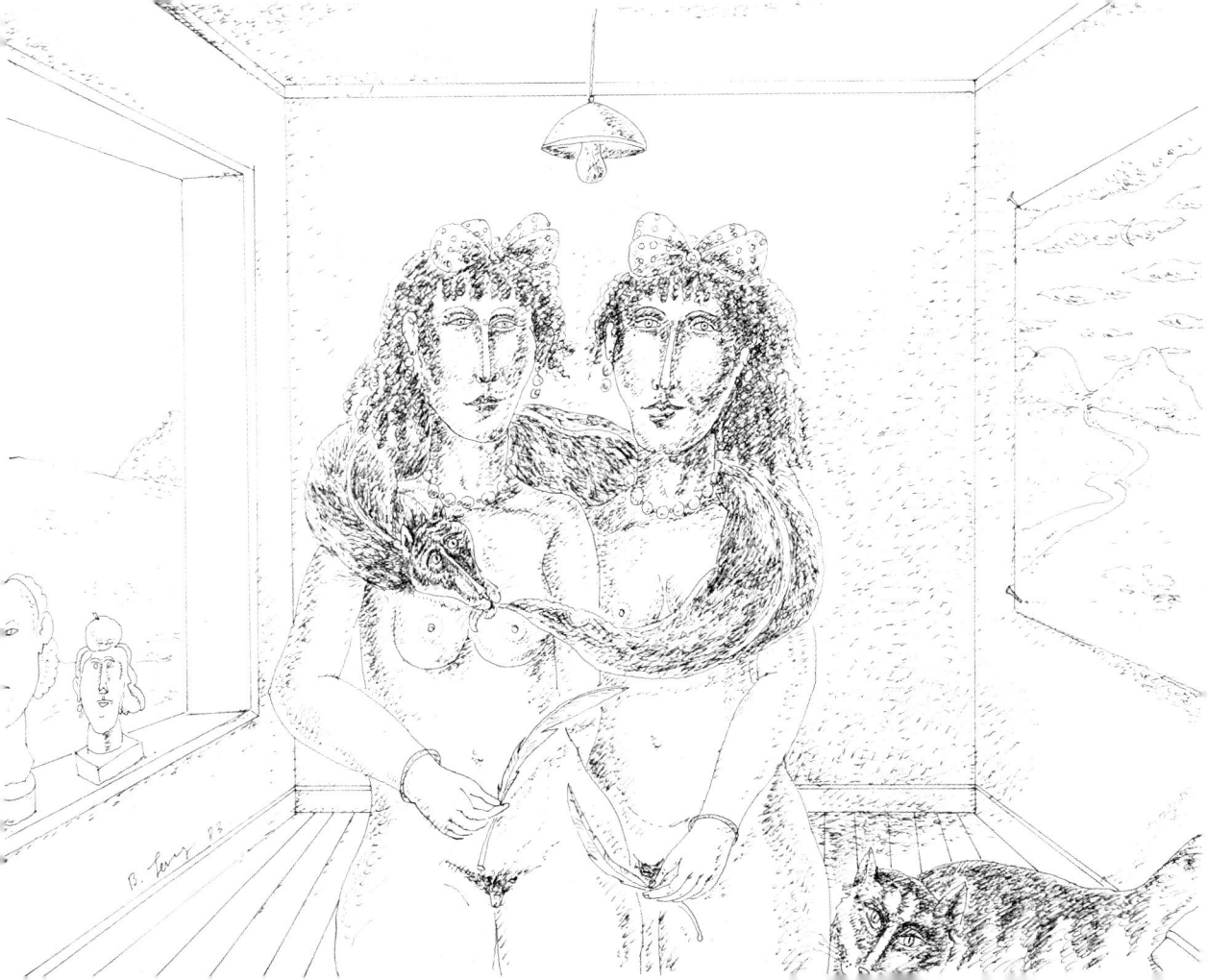

13. ***My Family on the Balcony***, 1983
 graphite on paper
 22-1/2 x 30 inches

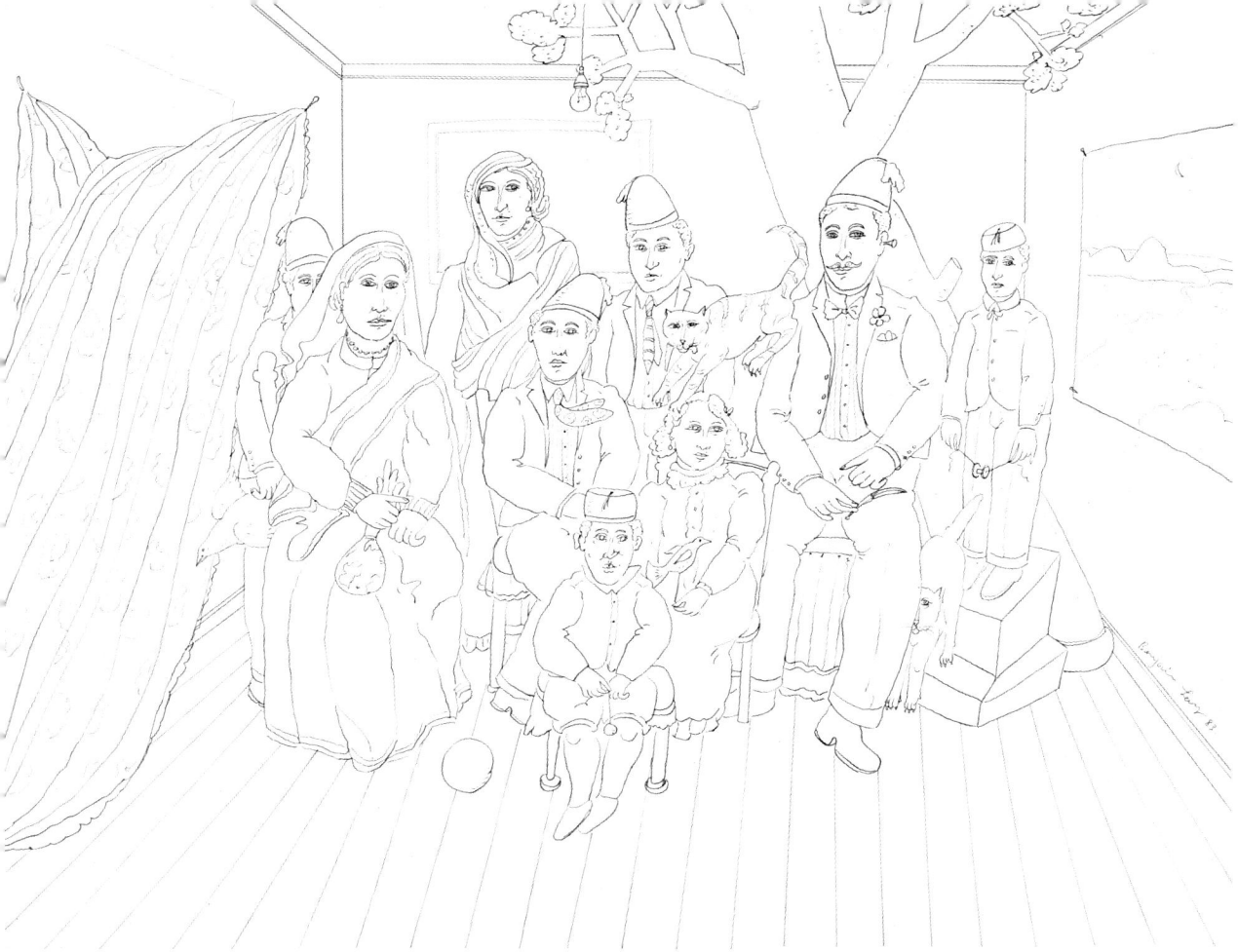

14. ***My Father, My Aunt and My Uncle***, 1983
 graphite on paper
 30 x 22-1/2 inches

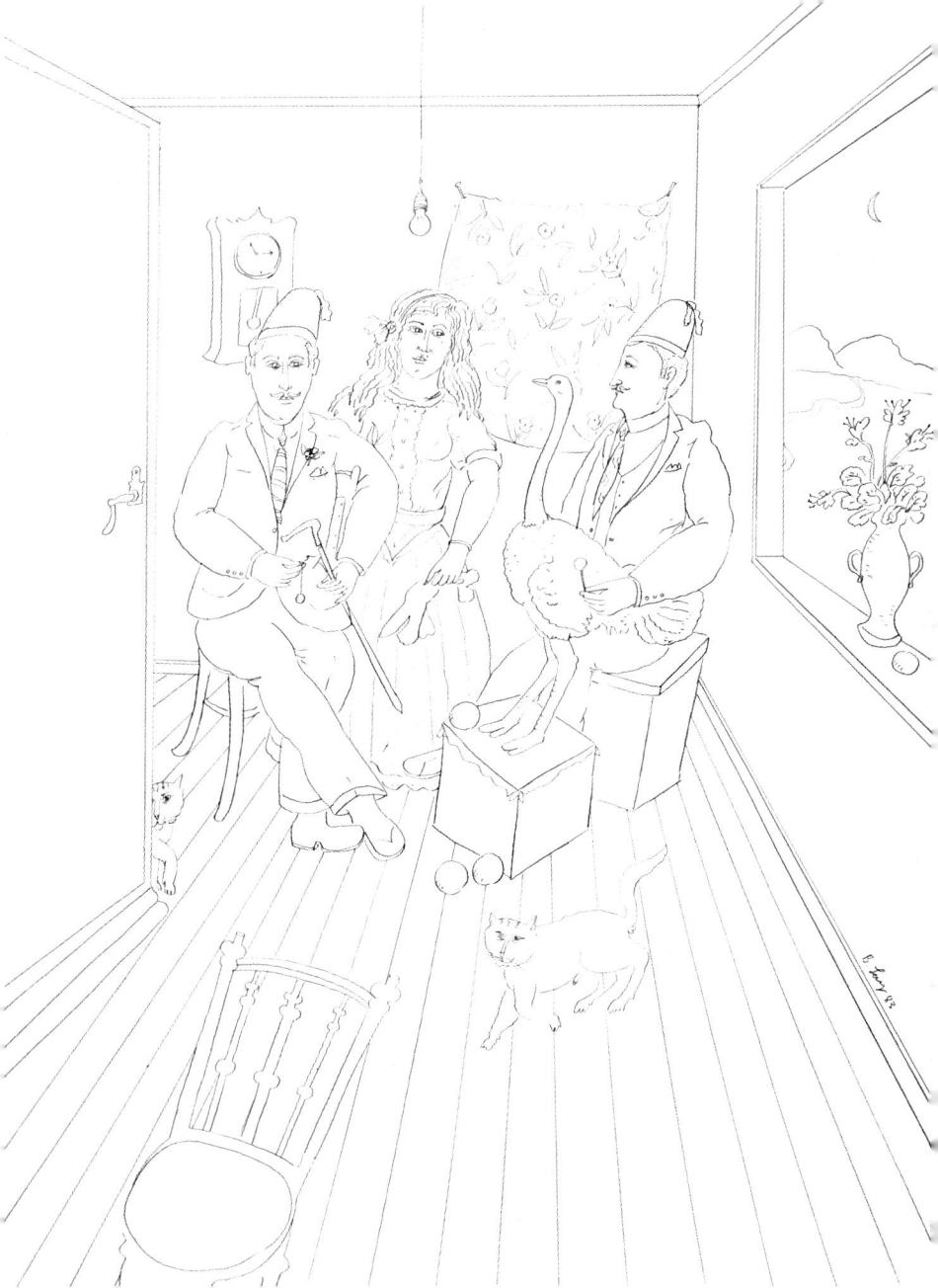

19. *Posing,* 1985
ink on paper
11-1/4 x 15 inches

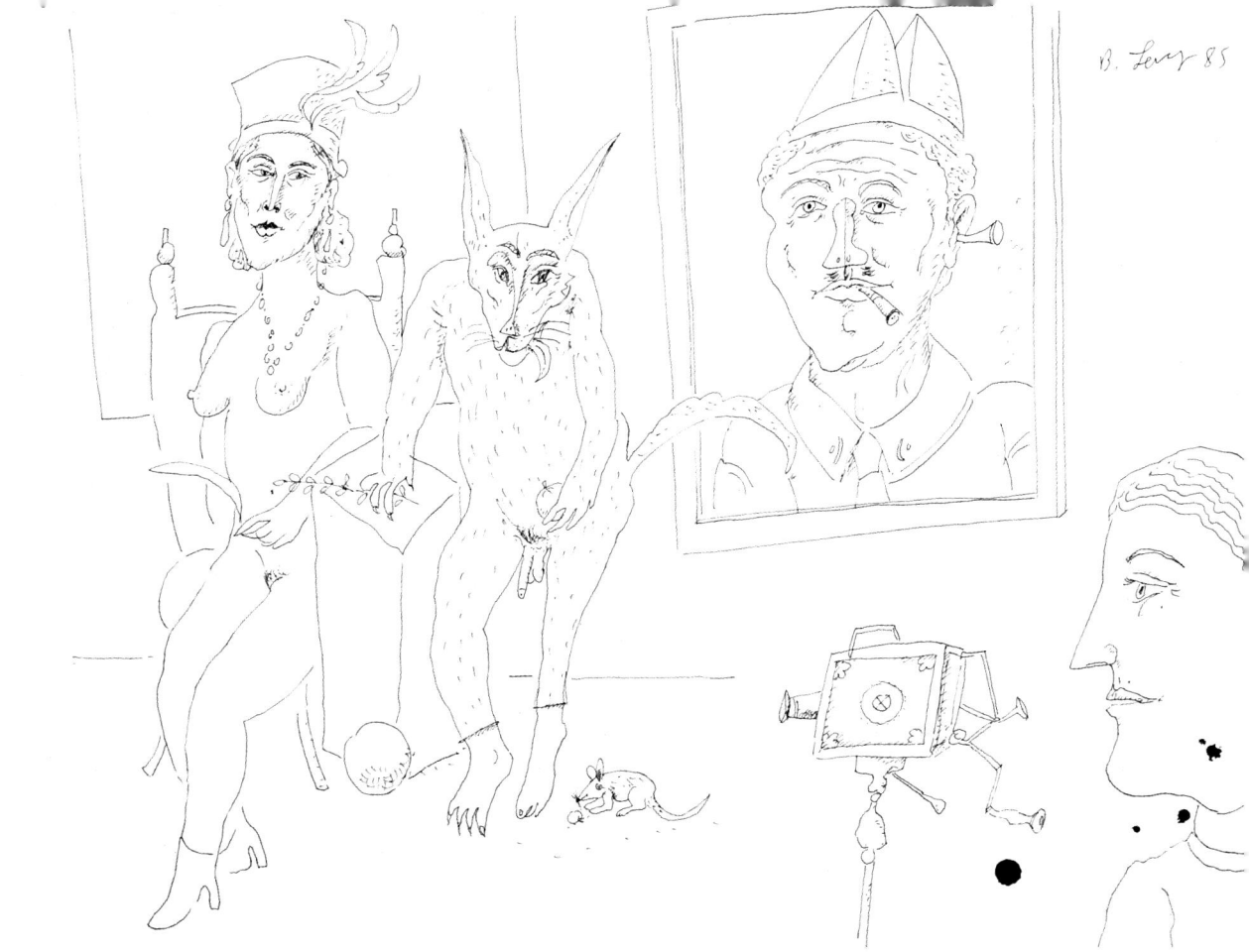

B. Levy 85

20. *Mystery Guests,* 1986
ink on paper
11 x 15 inches

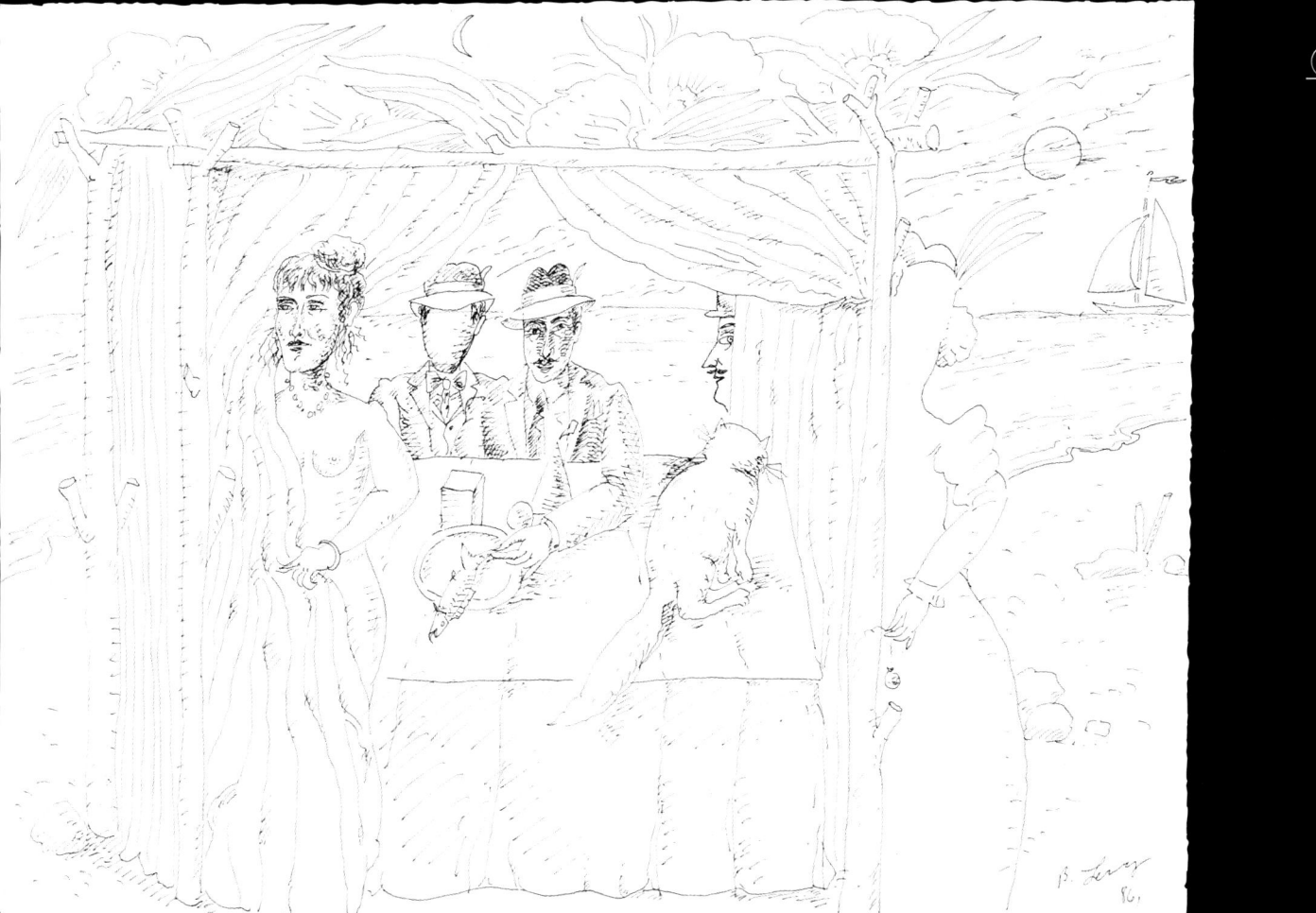

26. ***My Family on the Beach***, 1990
graphite on paper
22-1/4 x 30 inches

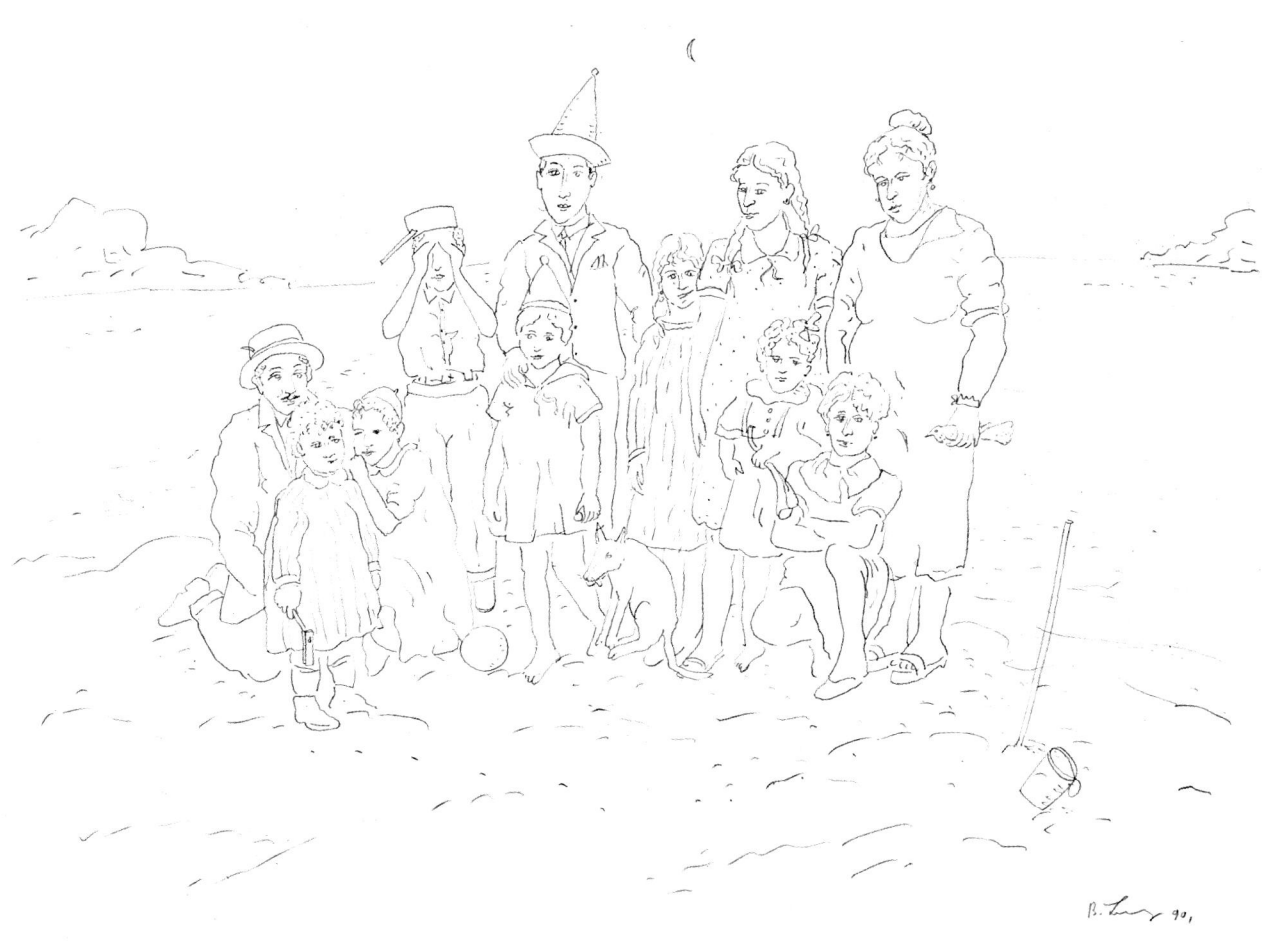

32. *The Visit*, 1991
ink on paper
11 x 15 inches

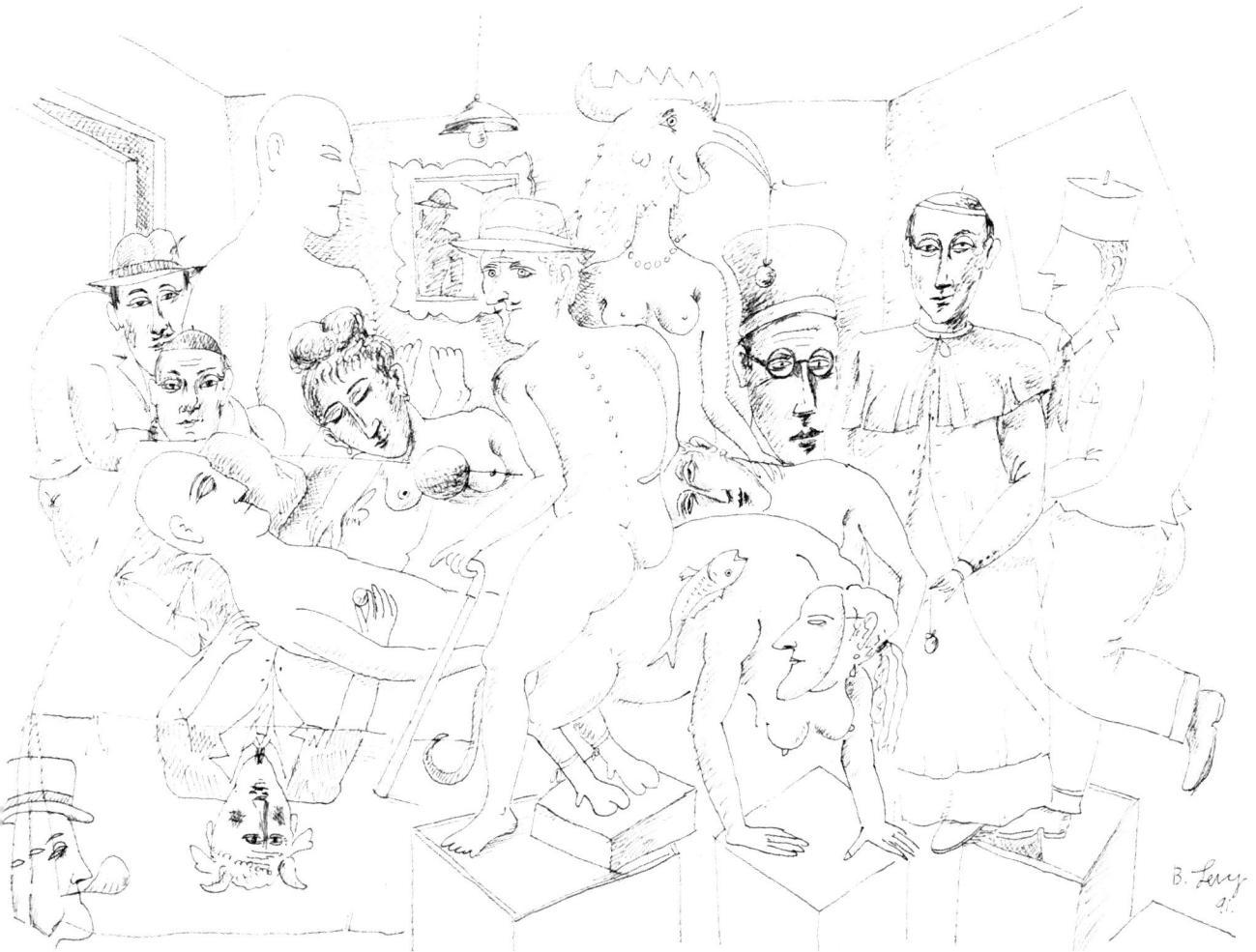

B. Levy
91

46. *Temptation*, 1995
 ink on paper
 11 x 15 inches

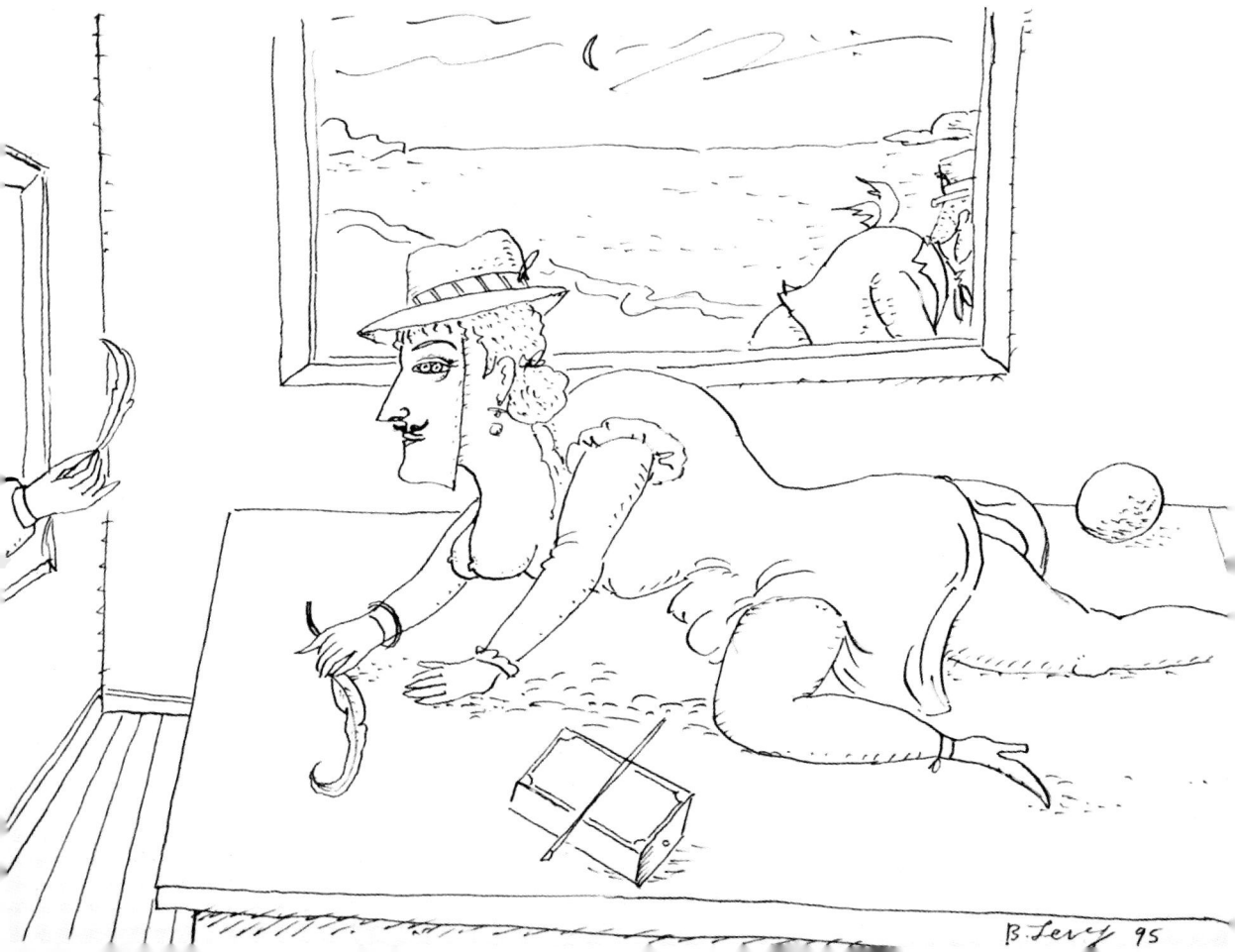

B. Levy 95

52. *My LIttle Angel*, 1996
ink on paper
15 x 11-1/4 inches

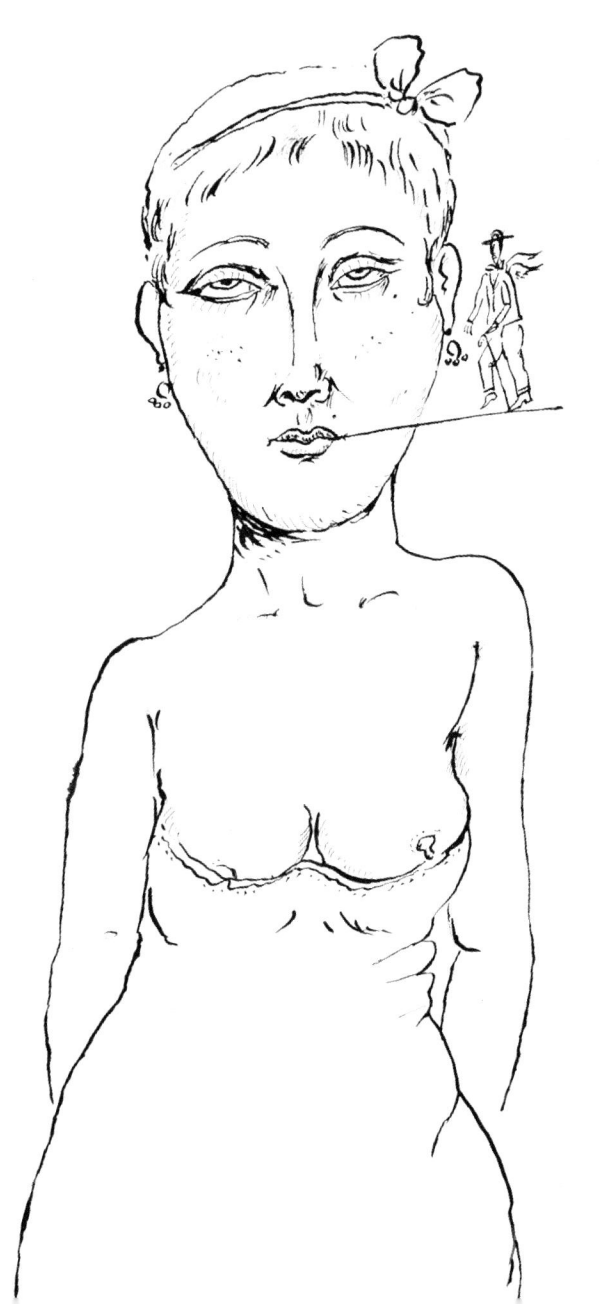

B. Levy 96.

55. *What's Awaiting Us?*, 1996
 ink on paper
 11 x 15-1/4 inches

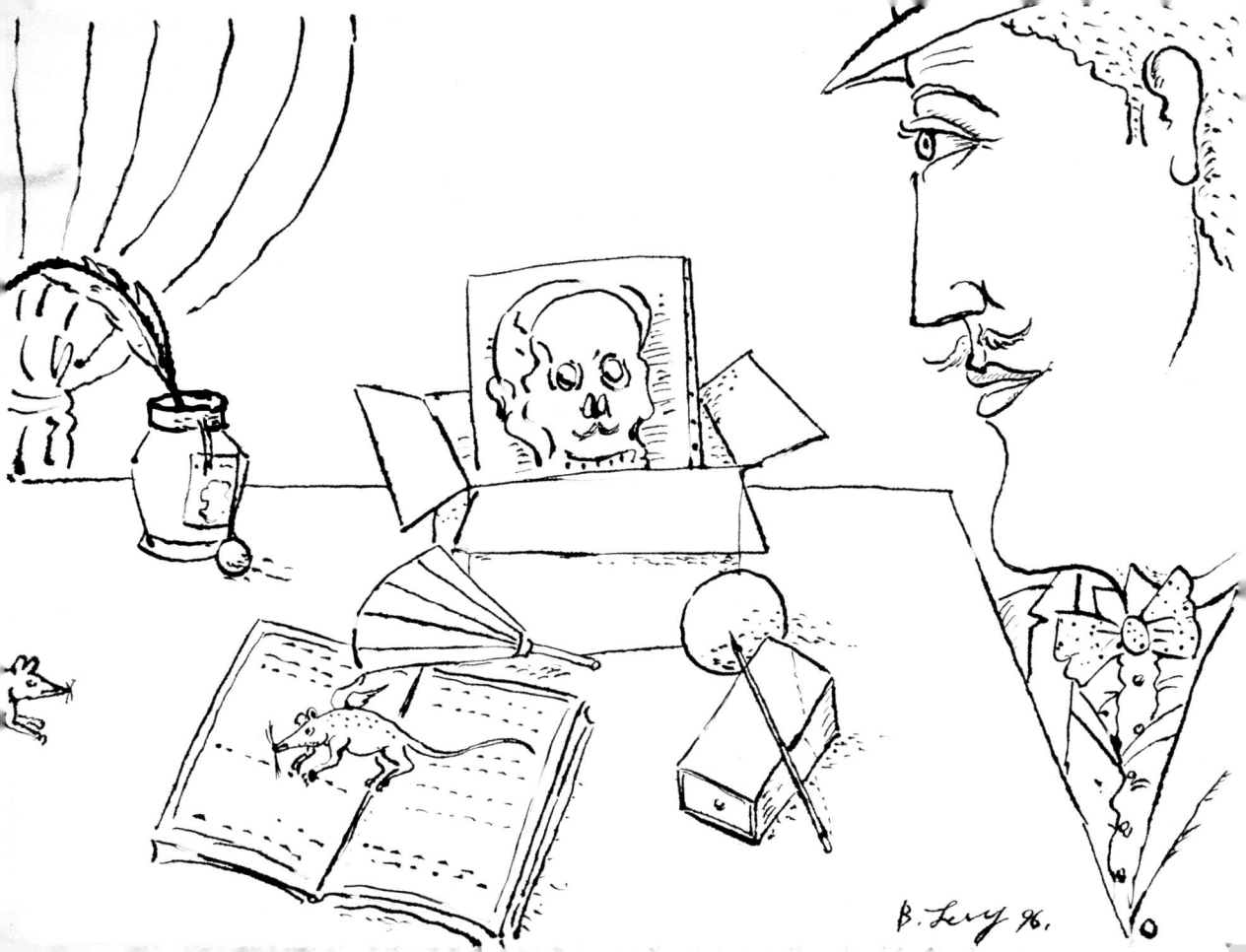

B. Levy 96.

1. **_The Observer_**, no date
 gouache on cardboard cutout
 12-1/8 x 7-1/8 inches

4. ***Sharon and Ofer's Wedding,*** no date
watercolor and graphite on paper
23-3/4 x 22 inches

36. *Birdland,* 1993
watercolor on paper envelope
15-5/8 x 12-5/8 inches

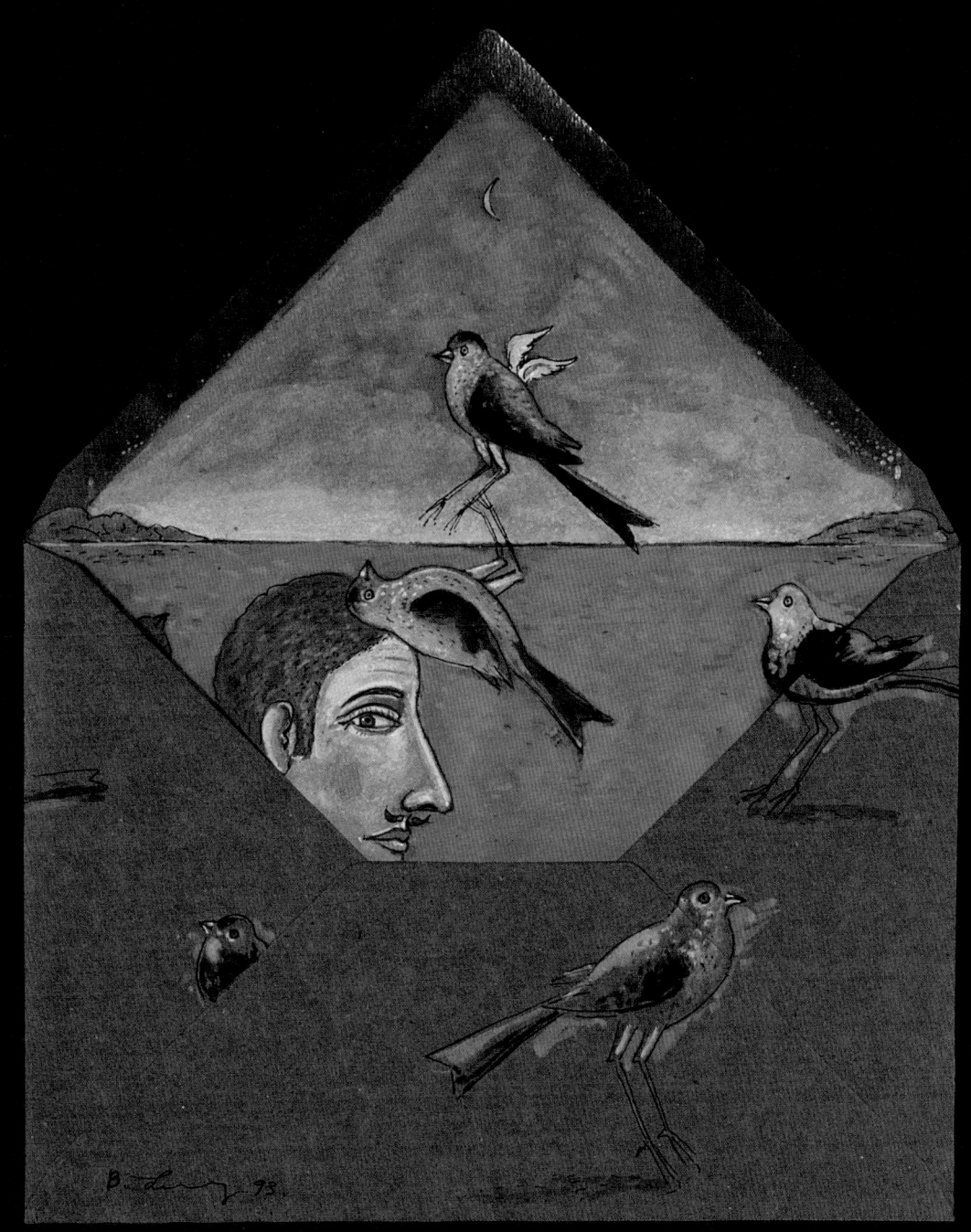

37. ***The Young Soldier***, 1993
watercolor on paper
19-1/2 x 15 inches

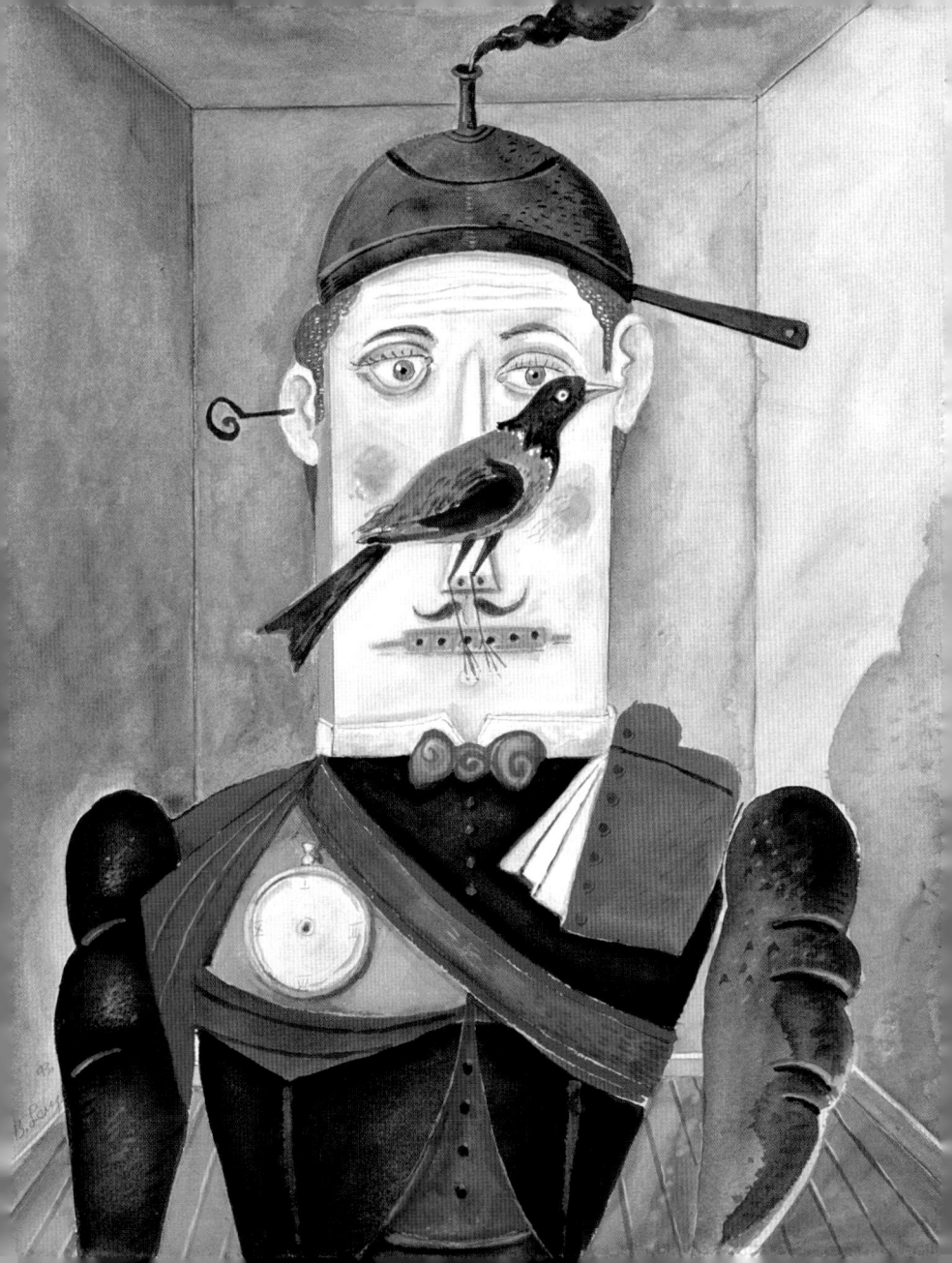

39. *Let Me Hear You Sing*, 1994
 watercolor on cardboard box
 21-5/8 x 10 inches

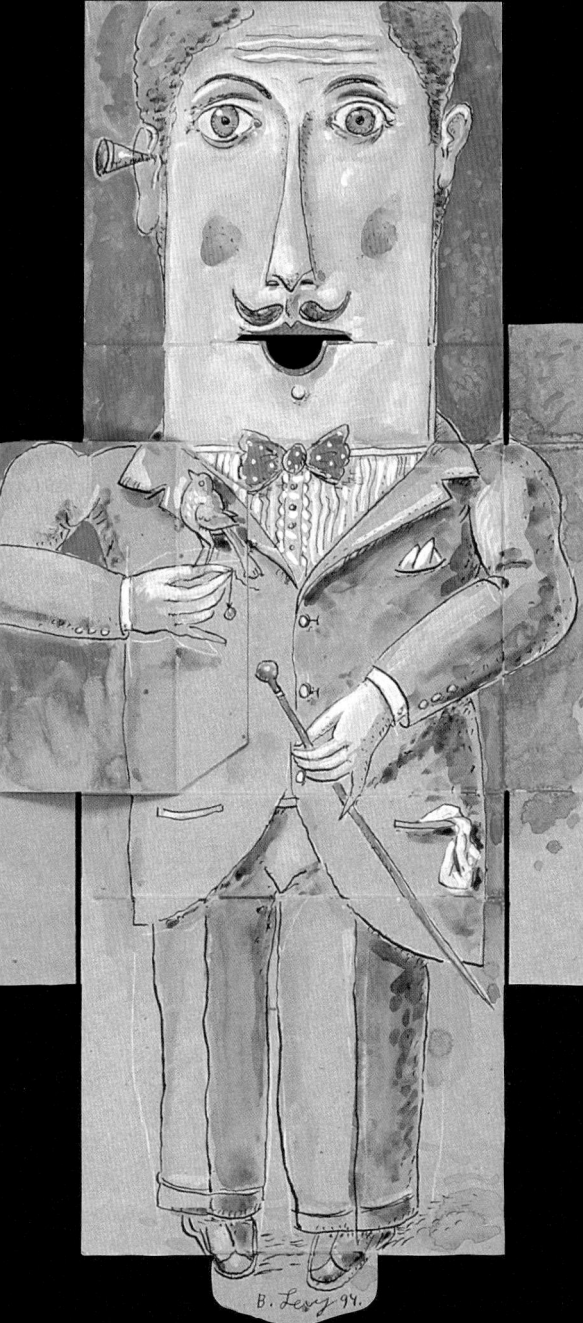

B. Levy 94.

42. ***Who Am I?***, 1995
 gouache on paper
 12-3/4 x 10 inches

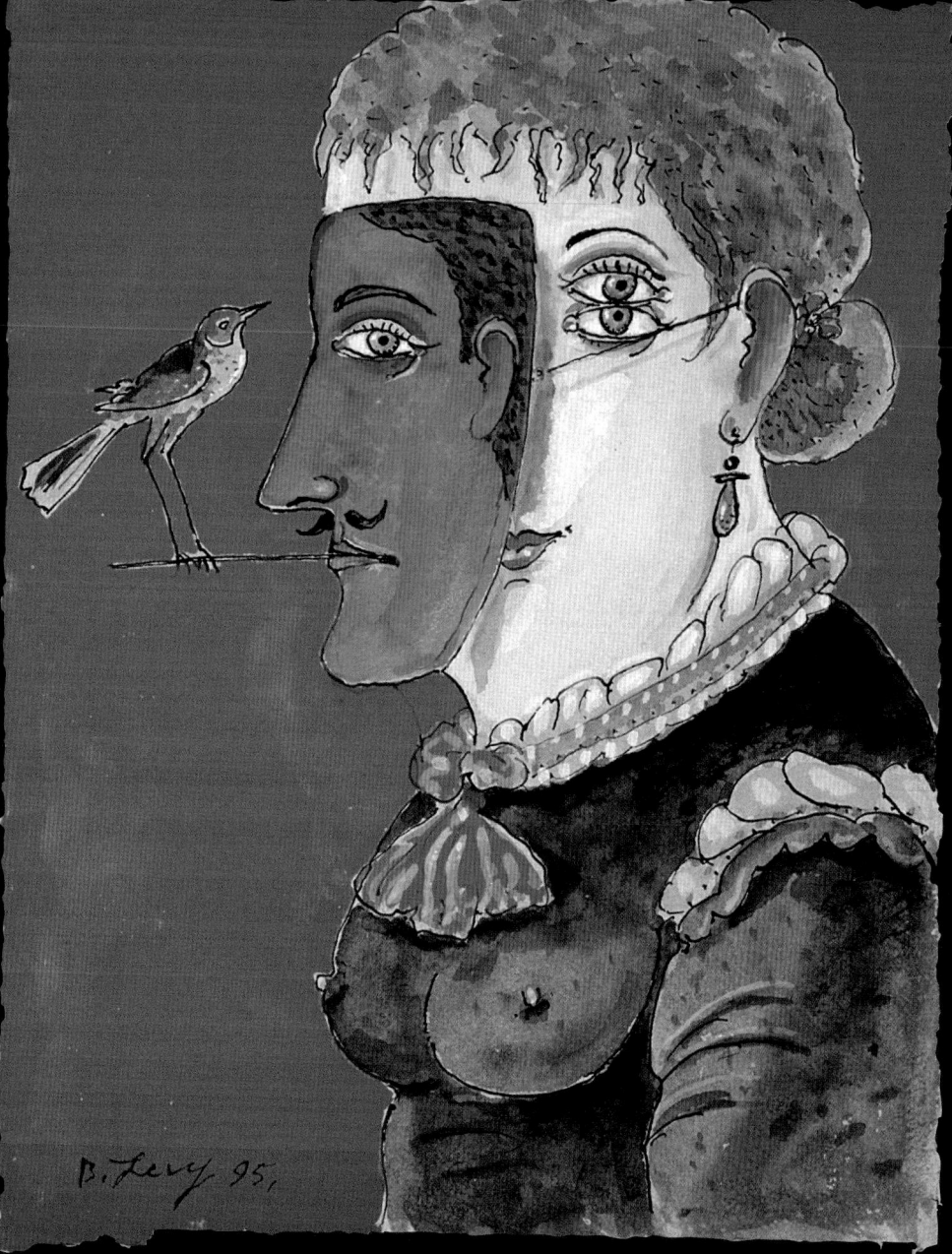

43. *Balancing Act (Man)*, 1995
 gouache on paper
 11 x 15-3/4 inches

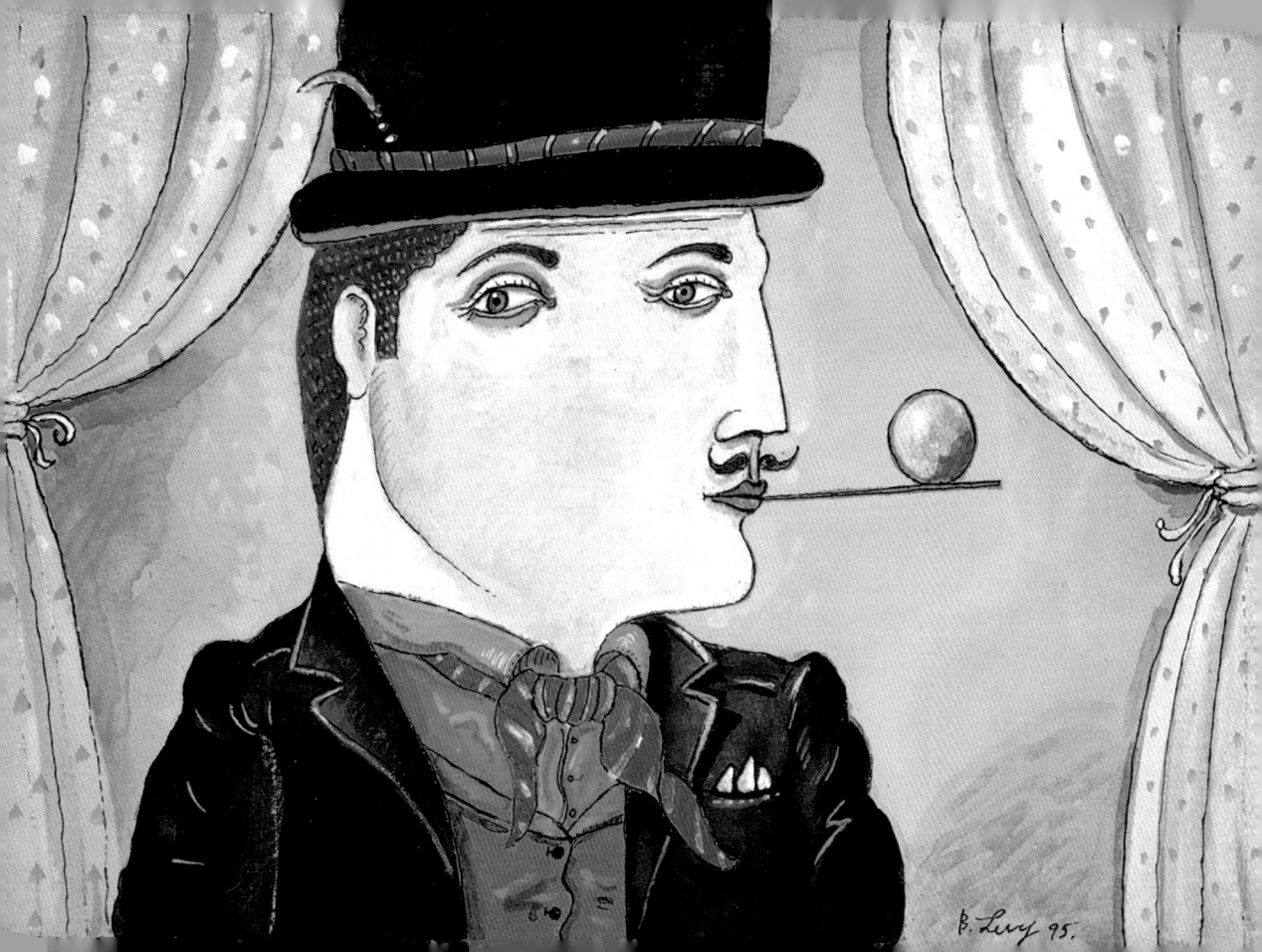

44. *Sitting Woman with Cat*, 1995
watercolor and gouache on paper
15 x 11 inches

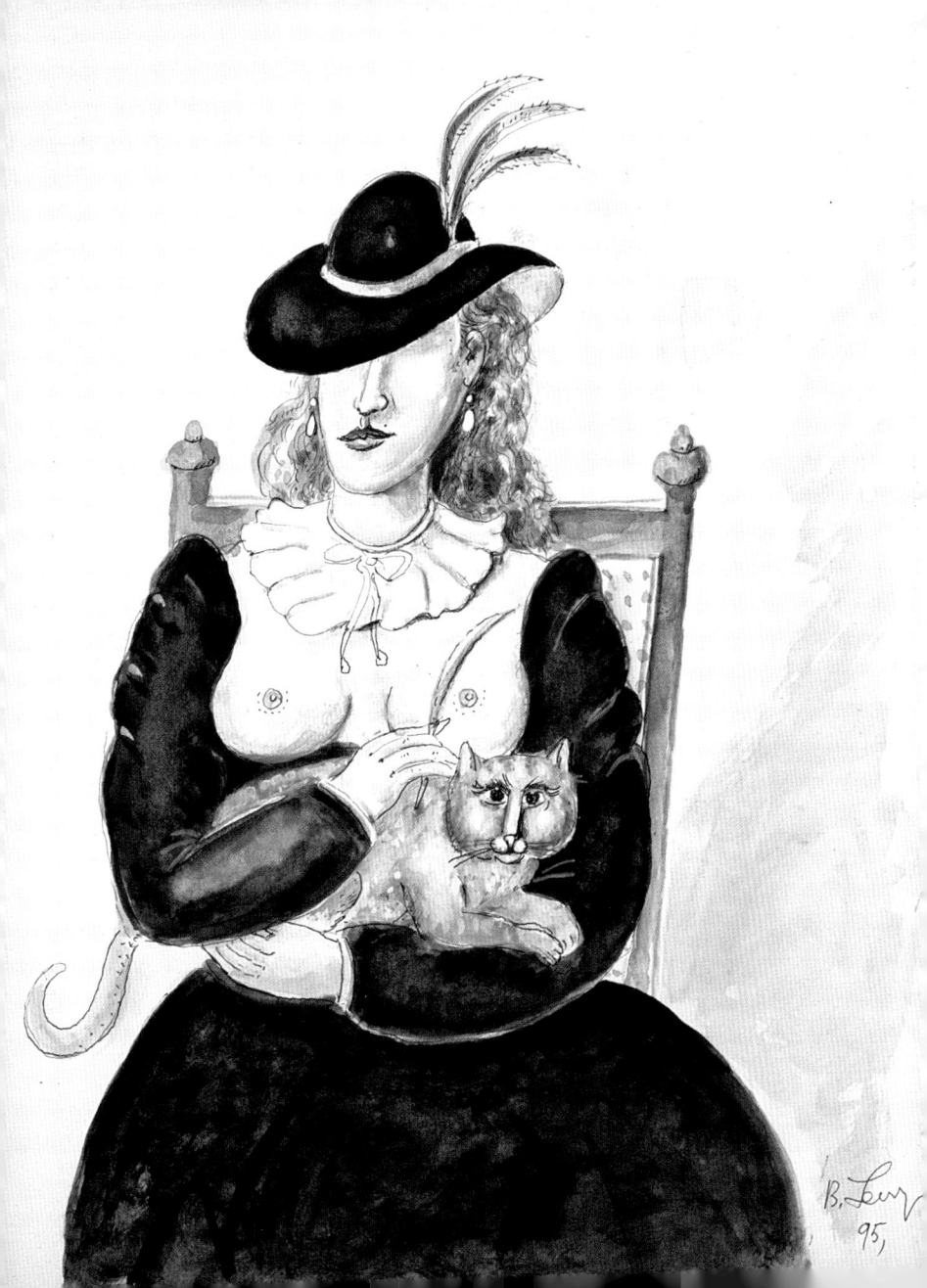

50. ***Double Mouth,*** 1996
watercolor on paper
15 x 11-1/4 inches

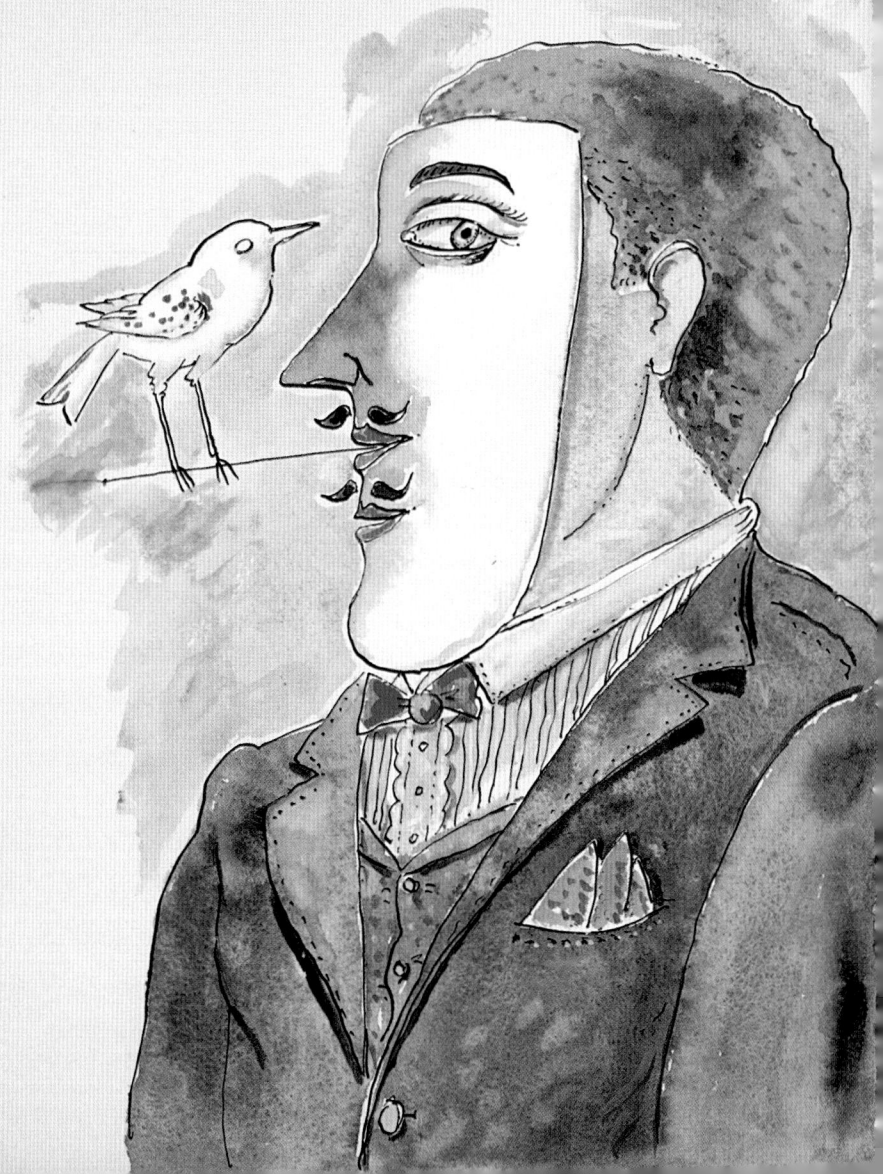

51. *The Acrobat*, 1996
 watercolor on paper
 11 x 15-1/4 inches

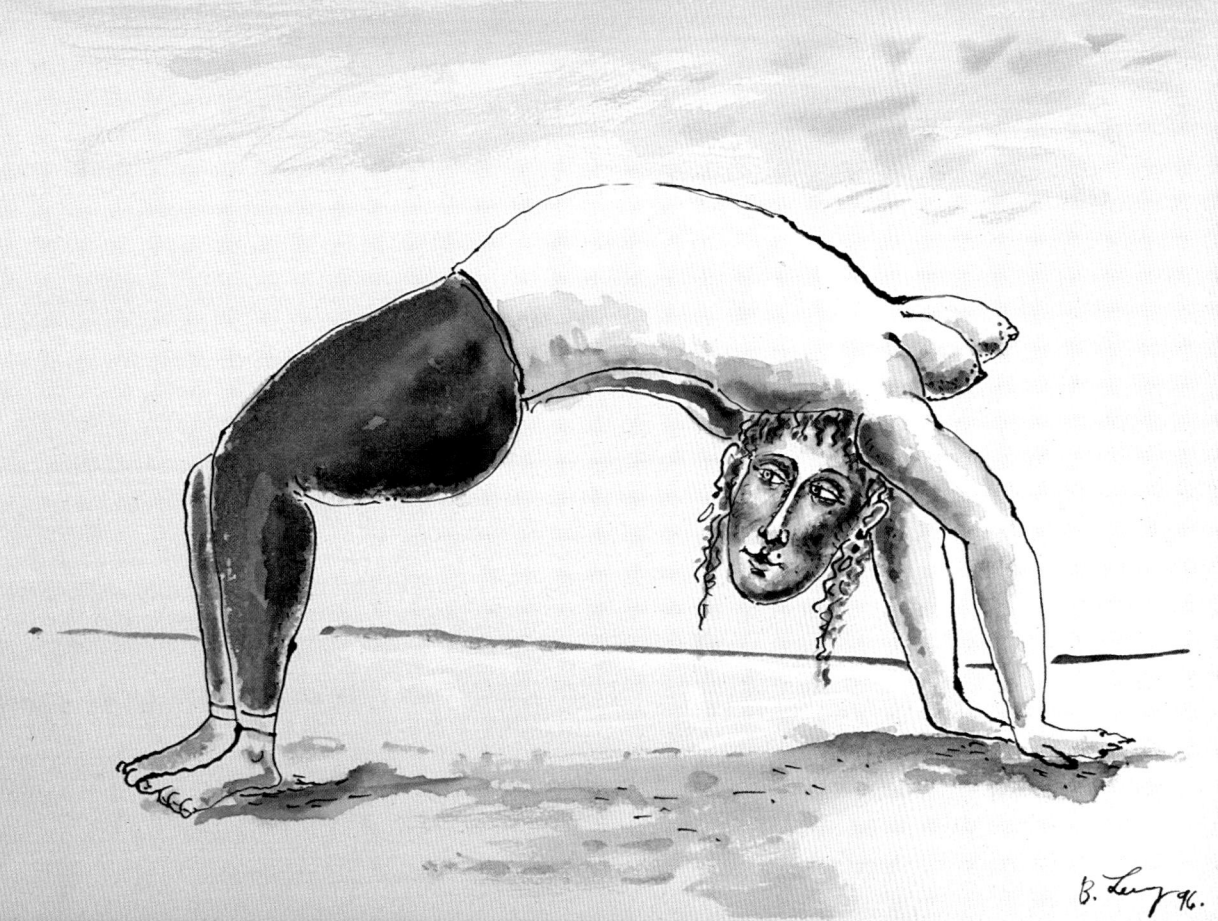

B. Lenz 96.

57. *Bathing,* 1996
 watercolor on paper
 17 x 13-3/4 inches

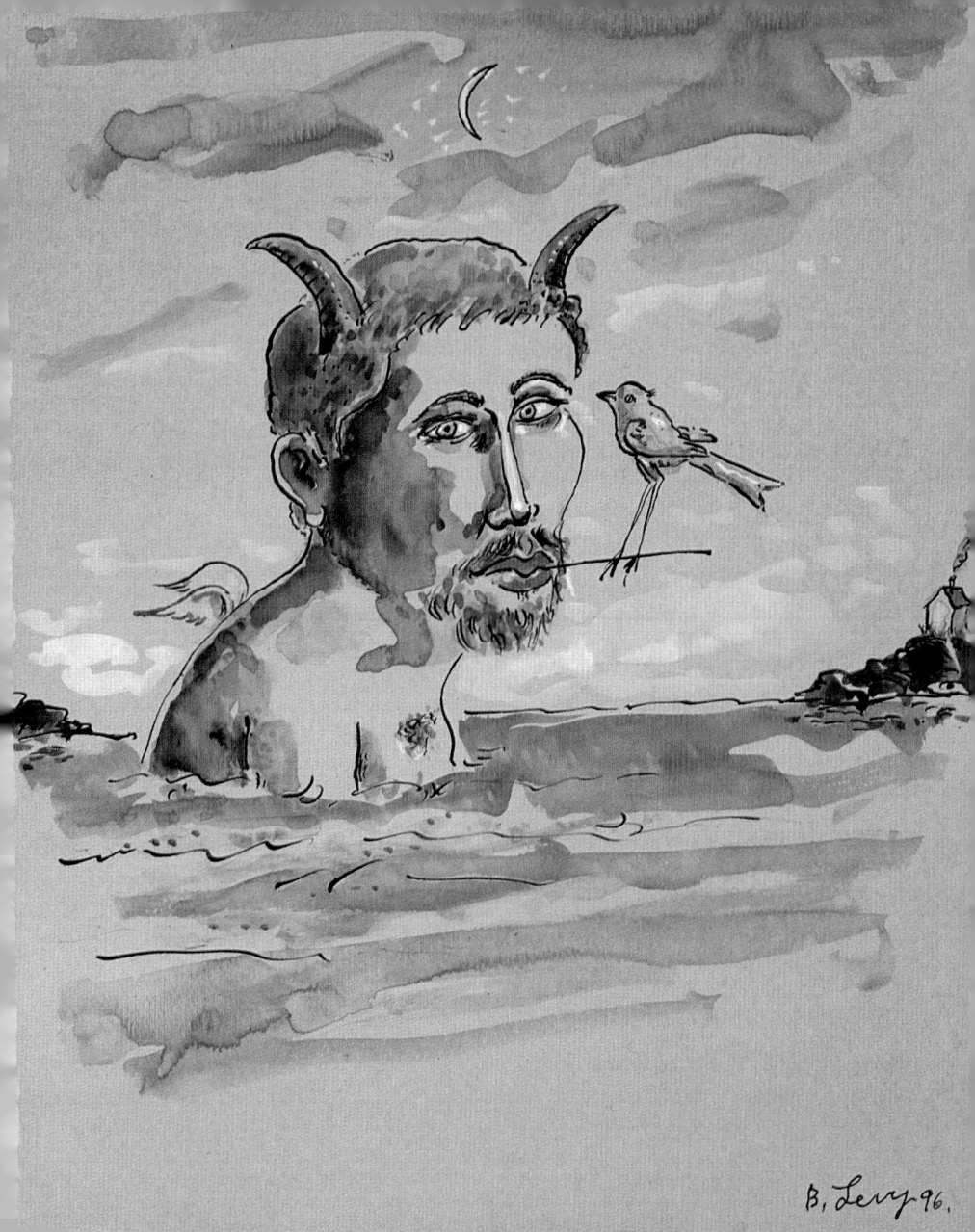

B. Levy 96.

59. *The Beautiful Couple*, 1997
 gouache on paper
 14-3/4 x 19-1/2 inches

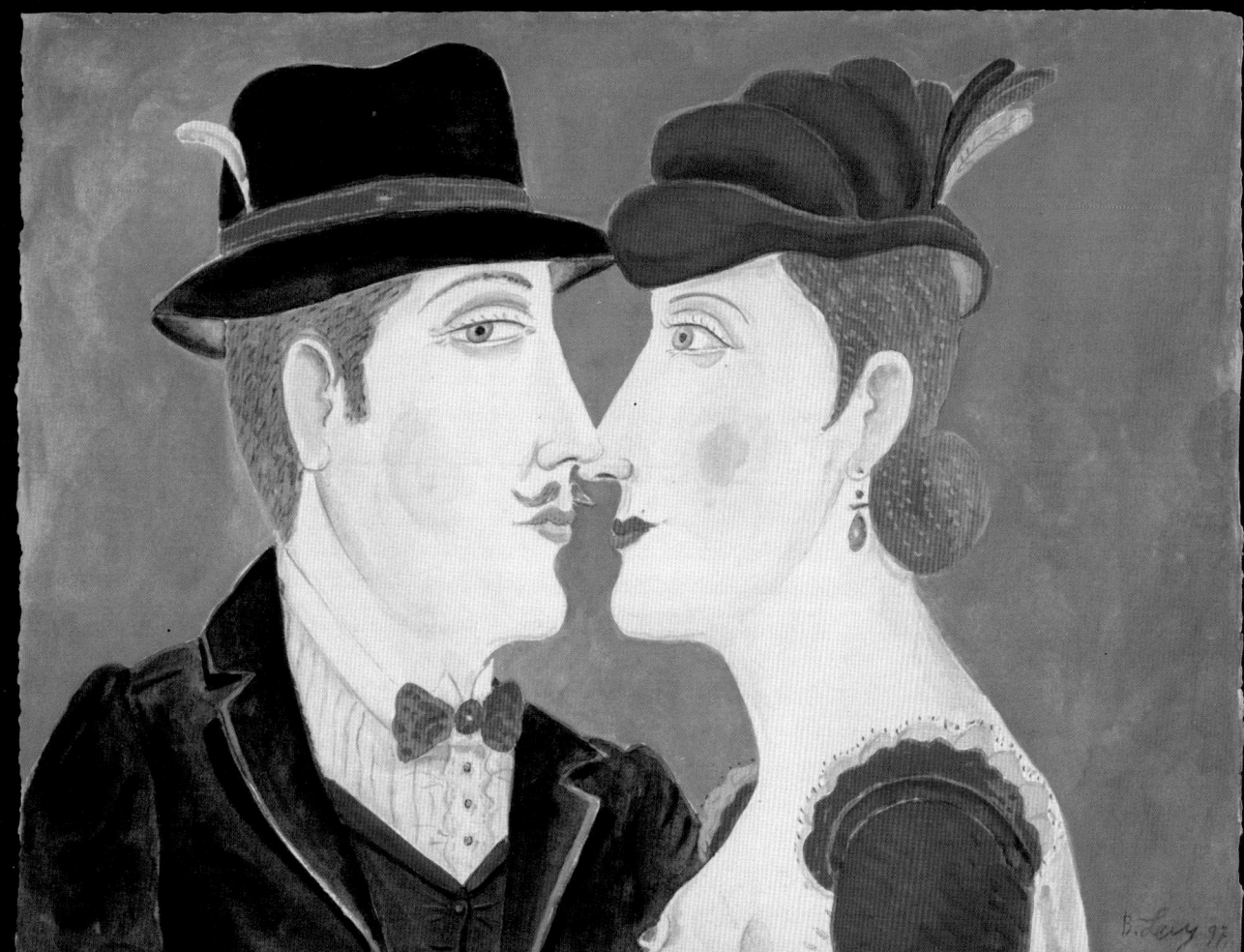

60. *Anonymous Letter*, 1997
 gouache on paper
 15-1/2 x 11 inches

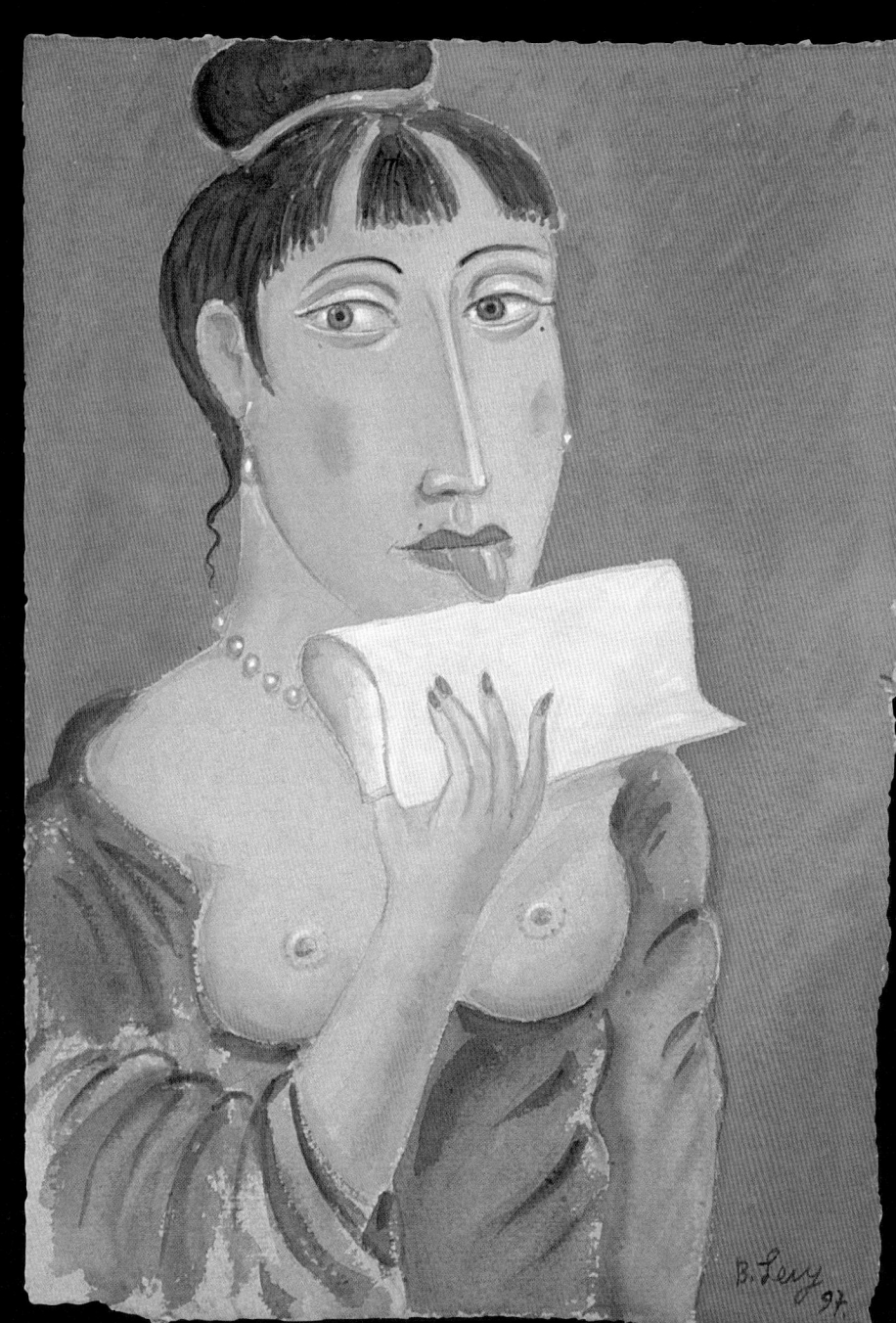

Catalog of the Exhibition

All works are lent by the artist. Measurements are height preceding width. Illustrated works are indicated by an asterisk (*).

* 1. **The Observer**, no date
gouache on cardboard cutout
12-1/8 x 7-1/8 inches

2. **My Red Tie**, no date
watercolor on cardboard cutout
12-1/8 x 7-1/8 inches

3. **In Uniform**, no date
gouache on cardboard cutout
12-1/8 x 6-7/8 inches

* 4. **Sharon and Ofer's Wedding**, no date
watercolor and graphite on paper
23-3/4 x 22 inches

* 5. **Balancing Act (Woman)**, no date
watercolor on paper
13 x 10 inches

6. **The Goatee**, no date
gouache on paper
14-1/2 x 8-1/8 inches

7. **The Artist's Studio**, no date
ink wash on paper
11-1/4 x 15 inches

8. **Taking My Pet for a Walk**, 1982
watercolor and ink on paper
15-3/4 x 11-1/4 inches

9. **Lovers in the Field**, 1983
ink on paper
11-1/8 x 15 inches

* 10. **Family Picture**, 1983
graphite on paper
15 x 19 inches

* 11. **Sisters**, 1983
ink on paper
15 x 19 inches

12. **Give Me a Hand**, 1983
ink on paper
19 x 15 inches

* 13. **My Family on the Balcony**, 1983
graphite on paper
22-1/2 x 30 inches

* 14. **My Father, My Aunt and My Uncle**, 1983
graphite on paper
30 x 22-1/2 inches

15. **Friends**, 1984
watercolor and ink on paper
11 x 15-1/16 inches

16. **On the Balcony**, 1984
ink on paper
11-1/8 x 15-1/8 inches

17. **On a Sunny Day**, 1984
watercolor and ink on paper
15 x 11 inches

18. **Faces**, 1985
ink on paper
19-1/4 x 15 inches

* 19. **Posing**, 1985
ink on paper
11-1/4 x 15 inches

* 20. **Mystery Guests**, 1986
ink on paper
11 x 15 inches

21. **Woman and Mirror**, 1987
watercolor on paper
15 x 11 inches

22. **The Gathering**, 1987
ink on paper
11-1/4 x 15 inches

23. **Untitled**, 1988
ink on paper
11 x 15 inches

24. **Talk to Me**, 1989
watercolor and ink on paper
11-1/4 x 14-3/4 inches

25. **Dreaming**, 1990
ink on paper
11-1/8 x 15 inches

* 26. **My Family on the Beach**, 1990
graphite on paper
22-1/4 x 30 inches

27. **My Studio**, 1990
ink on paper
22-1/4 x 30 inches

28. *A Guest in My Studio*, 1990
graphite on paper
22-1/4 x 30 inches

29. *Diana*, 1990
graphite on paper
29 x 23 inches

30. *Growing Horns (Woman)*, 1990
watercolor on paper
14-1/2 x 11-1/2 inches

31. *Voyeur*, 1990
ink on paper
14-1/2 x 11-1/2 inches

* 32. *The Visit*, 1991
ink on paper
11 x 15 inches

33. *Growing Horns (Boy)*, 1991
graphite on paper
14-7/8 x 11 inches

34. *The Magician*, 1992
graphite on paper
15 x 19-1/4 inches

35. *Untitled*, 1993
ink on paper
11-1/4 x 15 inches

* 36. *Birdland*, 1993
watercolor on paper envelope
15-5/8 x 12-5/8 inches

* 37. *The Young Soldier*, 1993
watercolor on paper
19-1/2 x 15 inches

38. *Growing Horns (Sitting Man)*, 1993
ink on paper
15 x 11 inches

* 39. *Let Me Hear You Sing*, 1994
watercolor on cardboard box
21-5/8 x 10 inches

40. *Caged In*, 1994
ink on paper
15 x 11 inches

41. *Literally*, 1995
watercolor and ink on paper
11-1/4 x 11 inches

* 42. *Who Am I?*, 1995
gouache on paper
12-3/4 x 10 inches

* 43. *Balancing Act (Man)*, 1995
gouache on paper
11 x 15-3/4 inches

* 44. *Sitting Woman with Cat*, 1995
watercolor and gouache on paper
15 x 11 inches

45. *Reclining Woman with Cat*, 1995
watercolor and gouache on paper
11 x 15 inches

* 46. *Temptation*, 1995
ink on paper
11 x 15 inches

47. *Is It an Angel?*, 1995
ink on paper
11 x 15 inches

48. *Who, Why, Where?*, 1996
watercolor and ink on paper
11-1/4 x 15 inches

49. *Animal Fantasy*, 1996
ink on paper
11-1/2 x 15 inches

* 50. *Double Mouth*, 1996
watercolor on paper
15 x 11-1/4 inches

* 51. *The Acrobat*, 1996
watercolor on paper
11 x 15-1/4 inches

* 52. *My LIttle Angel*, 1996
ink on paper
15 x 11-1/4 inches

53. *My Own Mythology*, 1996
ink on paper
11-1/4 x 15 inches

54. *Ofer the Doctor*, 1996
watercolor and ink on paper
11-1/4 x 15 inches

* 55. *What's Awaiting Us?*, 1996
ink on paper
11 x 15-1/4 inches

56. *Seeing Through One Eye*, 1996
ink on paper
15 x 11 inches

* 57. *Bathing*, 1996
watercolor on paper
17 x 13-3/4 inches

58. *Split Face*, 1997
watercolor and gouache on paper
15-3/4 x 11-1/4 inches

* 59. *The Beautiful Couple*, 1997
gouache on paper
14-3/4 x 19-1/2 inches

* 60. *Anonymous Letter*, 1997
gouache on paper
15-1/2 x 11 inches

SELECTED EXHIBITIONS AND COLLECTIONS

ONE-PERSON EXHIBITIONS:

1998 Bryant Galleries, New Orleans, Louisiana
1997 Museo Sefardi, Toledo, Spain
1995 Nahan Gallery, New Orleans, Louisiana
 National Arts Club, New York, New York
1994 Nahan Gallery, New Orleans, Louisiana
 The Dwight Frederick Boyden Gallery, Saint Mary's
 College of Maryland, Saint Mary's City, Maryland
1993 Nahan Gallery, New Orleans, Louisiana
 B'nai B'rith Klutznick National Jewish Museum, Washington, D.C.
1992 Galerie Maguy, Geneva, Switzerland
1991 La Gravida Gallery, Rome, Italy
 Roslyn Fine Arts, Philadelphia, Pennsylvania
 Union League Club, New York, New York
 Yeshiva University Museum, New York, New York
1990 Roslyn Fine Arts, Margate, New Jersey
1985 Goldman Fine Art, Washington, D.C.
 Galerie Fabien Boulakia, Paris, France
 Sander Gallery, Daytona Beach, Florida
1983 Chrysalis Gallery, Melbourne, Victoria, Australia
 Holdsworth Galleries, Woollahara, Australia
1982 The University of South Carolina McKissick Museum,
 Columbia, South Carolina
 Editions Galleries, South Melbourne, Victoria, Australia
1981 Galerij S65, Aalst, Belgium
1980 Jas Gallery, Utrecht, Holland
 Galerij S65, Aalst, Belgium
 National Print Center, Kasterlee, Belgium
 Keneda Gallery, Tokyo, Japan
 Marquis Gallery, Flisingen, Holland
 Circle Gallery, Oostende, Belgium
 Montjoi Gallery, Brussels, Belgium
1979 Galerij S65, Aalst, Belgium
 L'Affiche Gallery, New York, New York
 Tara Gallery, Hilversum, Holland
 Columbia Museum of Art, Columbia, South Carolina
 Wetering Gallery, Amsterdam, Holland
 Jewish Center, West Hartford, Connecticut
 Ordan Gallery, Ramat Hasharon, Israel
1978 Hedendaagse Kunst, Utrecht, Holland
 Galerij S65, Aalst, Belgium
 Palm Springs Desert Museum, Palm Springs, California
1976 Le Cadre Gallery, Toronto, Canada
 Tel Aviv Museum of Art, Tel Aviv, Israel
 Delson Richter Gallery, Tel Aviv-Jaffa, Israel
 Delson Richter Gallery, Jerusalem, Israel

1975 Krupp Gerlach Gallery, New Jersey
 Wollheims-Rosequist Galleries, Tucson, Arizona
 Galerie T, Amsterdam, Holland
1974 Bauhaus II Studio of Contemporary Art, Green Farms,
 Connecticut
 Ordan Gallery, Ramat Hasharon, Israel
1973 Israel Art Gallery, New York, New York
 Museo de Arte Contemporaneo, Panama City, Panama
 Halsband Gallery, New York, New York
1972 Galerias del Centro Depuritivo, Mexico City, Mexico
1971 Aleph Gallery, Mexico City, Mexico
 Everyman Gallery, New York, New York
 Graphic Art Gallery, Tel Aviv, Israel
 Miami Museum of Modern Art, Miami, Florida
1970 New Haven Jewish Center, New Haven, Connecticutt
1968 Everyman Gallery, New York, New York
1966 Israeli Art Gallery, New York, New York
 Morris Art Gallery, Woodstock, New York
1964 Tchermerinsky Gallery, Tel Aviv, Israel
1961 Dugit Gallery, Tel Aviv, Israel

GROUP EXHIBITIONS:

1998 *Firenze Biennale*, Palazzo degli Affari, Florence, Italy
 Palm Beach Contemporary Art and Design Fair,
 Georgetown Gallery, Palm Beach, Florida
1997 Keogh & Riehlman Fine Art, New York, New York
 *Shalom Haver: 30 Artistic Responses to the Life and Tragic
 Death of Yitzhak Rabin*, The George Washington
 University, Washington, D.C.
 Traveled to: Museum of Art, Fort Lauderdale, Florida
1992 *Sefarad '92*, Museo Sefardi, Toledo, Spain
 Traveled to: Sarajevo, Belgrade and Tel-Aviv
 Lillian Heidenberg Miniature Exhibition, New York, New York
1988 Festivales de Navara, Pampalona, Spain
 Golem: Danger, Deliverance and Art, The Jewish Museum,
 New York, New York
 Texas Technical University, Lubbock, Texas
 Hatchison Gallery, Birmingham, Alabama
 Galing J.L., Oostende, Belgium
1984 Bradley Gallery, Southwest Heritage, Inc., Naples, Florida
 Edwin A. Ulrich Museum, Wichita State University,
 Wichita, Kansas
 Muskegon Museum of Art, Muskegon, Michigan
 San Jose Museum of Art, San Jose, California
 Laumeier International Sculpture Park, Saint Louis, Missouri
 Schick Art Gallery, Skidmore College, Saratoga Springs, New York
 Selection One, Galerie Fabien Boulakia, Paris, France

Boca Raton Museum of Art, Boca Raton, Florida
American Academy of Arts and Letters, New York, New York
Foire Internationale d'Art Contemporain, Galerie Fabien
 Boulakia, Paris, France
Tenafly Jewish Center, Tenafly, New Jersey
Lillian Heidenberg Miniature Exhibition, New York, New York

1983 American Academy of Arts and Letters, New York, New York
Colorado Springs Fine Arts Center, Colorado Springs, Colorado
Duke University Museum of Art, Durham, North Carolina
Western College for the Arts, Grand Junction, Colorado
Tacoma Art Museum, Tacoma, Washington

1982 *Art en la Carraterra*, Museo Vial, Venezuela
Editions Galleries, South Melbourne, Victoria, Australia

1981 *A Collector's Eye: The Olga Hirshhorn Collection,*
Smithsonian Institution Traveling Exhibition Service,
 Washington, D.C.
 Traveled to: Bruce Museum, Greenwich, Connecticut
Art Museum of South Texas, Corpus Christi, Texas
Florida International University, Miami, Florida
Cheekwood Fine Arts Center, Nashville, Tennessee
Meadows Museum of Art, Shreveport, Louisiana
Smith College Museum of Art, North Hampton, Massachussetts
Brunnier Gallery, Iowa State University, Ames, Iowa
Oakridge Community Art Center, Oakridge, Tennessee
Evansville Museum of Art and Science, Evansville, Indiana
Mansfield Art Center, Mansfield, Ohio
Santa Fe Community College, Gainesville, Florida
Arapahoe Community College, Littleton, Colorado

1978 Israel Museum, Jerusalem, Israel
1977 Galerie T, Amsterdam, Holland
The Cabinet, Sao Paolo, Brazil
1976 Galerie T, Amsterdam, Holland
1975 Galerie T, Amsterdam, Holland
Felicie, Paris, France
1974 LeCadre Gallery, Toronto, Canada
1973 Queens Museum, New York, New York

Posters from the USA, Tel Aviv Museum of Art, Tel Aviv, Israel
1972 Hedendaagse Kunst, Utrecht, Holland
1970 *Law and Justice,* Bar Association of New York City and
 national tour
1969 Georgetown Gallery, Washington, D.C.
Audubon Artist's Exhibition, New York, New York
1968 Lending Collection of the Museum of Modern Art,
 New York, New York
1966 Demana Gallery, New York, New York
1965 *Young Israeli Artists*, Artists Union Gallery, Tel Aviv, Israel
1962 Tel Aviv Museum of Art, Tel Aviv, Israel
Israel Museum, Jerusalem, Israel

PUBLIC AND INSTITUTIONAL COLLECTIONS

B'nai B'rith Klutznick National Jewish Museum, Washington, D.C.
The Corcoran Gallery of Art, Washington, D.C.
The Detroit Institute of Arts, Detroit, Michigan
Hedendaagse Kunst, Utrecht, Holland
The Hirshhorn Museum and Sculpture Garden, Washington, D.C.
Indianapolis Museum of Art, Indianapolis, Indiana
The Jewish Museum, New York, New York
McKissick Museum, Columbia, South Carolina
Museum of Arts and Sciences, Daytona Beach, Florida
Museum of Modern Art, Haifa, Israel
Museo de Arte Contemporaneo, Caracas, Venezuela
Museo de Arte Contemporaneo, Panama City, Panama
Museo Sefardi, Toledo, Spain
New Orleans Museum of Art, New Orleans, Louisiana
New York Public Library, New York, New York
The Olga Hirshhorn Collection, Washington, D.C.
Skirball Museum, Los Angeles, California
The Stedelijk Museum, Amsterdam, Holland
Tel Aviv Museum of Art, Tel Aviv, Israel
City of Tel Aviv, Tel Aviv, Israel
Yeshiva University Museum, New York, New York

SELECTED BIBLIOGRAPHY

PERIODICALS AND NEWSPAPERS

_____: "A Painting by Benjamin Levy in the Museum," *Noticias,* Museo Sefardi, illustration, Toledo, Spain, July-December, 1989.
Aviram, Batya. *Shalom Haver: 30 Artistic Responses to the Life and Tragic Death of Yitzhak Rabin,* Project Judaica Foundation, Washington, D.C., 1997
_____: "Benjamin Levy," *Kunstech's Nederland,* Utrecht, Holland, January 1, 1978.
_____: "Benjamin Levy: **Spel met herinneringen,**" *Kunst Beeld,* p.36, illustration, Brussels, Belgium, March 1978
Broido, Ethel. "Recent Prints from Israel," vol. xi, *Artist's Proof: The Annual of Prints and Printmaking,* pp. 82-87, Pratt Graphics Center, Greenwich, Connecticut, 1971.
D'Hondt, Roger: "De Maximal Art van Benjamin Levy," *De Voorpost,* Brussels, Belgium, February 3, 1978.
Duister, Frans: "Levy een Naief, Verteller," *Het Parool,* Amsterdam, Holland, March 13, 1978.

_____: "El MuseoVial: Una Experencia Inolvidable," illustration, *El Universal*, Culturales, Caracas, Venezuela, May 24, 1982.

_____: Gek, Dwaas en Eigenwijs," *Journal of the University of Utrecht*, Utrecht, Holland, February, 1978.

Juffermans, Jan: "Amusant Spel met de Familie Doorsnee," *Kunst kijken*, Amsterdam, Holland, December 1975.

Kalmann, Inge: "De bizarre visie van Benjamin Levy," *Nieuw Israelisch Weekblad*, Hedendaagse Kunst, p. 11 , Utrecht, Holland.

Kelk, Fanny: "Benjamin Levy uit New York: Sjeuig Talent in galerie T., Werk vol Herinnering," Amsterdam, Holland, December 1975.

Kohan, Horacio: "El Largo Viaje," *Raices* (Revisita Judia de Cultura) pp. 7-9, Madrid, Spain, 1989.

Kresh, Paul: "At Yeshiva Museum It's Mostly Sephardic," *The Jewish Weekly*, illustration, New York, New York, December 6-12, 1991.

_____:"La Foire Image," *L'Hebdo Suisse Romande*, Geneva, Switzerland, April 23, 1992.

Murphy, Drew. "Benjamin Levy: `Nobody is Really What He Seems,'" *Daytona Beach Sunday News-Journal*, illustration, Daytona Beach, Florida, March 3, 1985.

Nashon, Gad: "Yemenite Surrealism at National Arts Club," *Israel Shelanu*, New York, New York, August, 1995.

_____: "Benjamin Levy: Yemenite-Israeli Surrealist Exotic Artist," *Jewish Post*, New York, pp. 37-38, illustrations, April 1998.

Redeker, Hans: "Benjamin Levy: Innemend en ontwapenend kunstenaar," *Handelblad/NRC*, Amsterdam, Holland, December 31, 1975.

Restany, Pierre: "Benjamin Levy: Une Histoire de Famille," *Cimaise*, no. 175, pp. 45-56, illustration, Paris, France, April-May, 1985.

Soltes, Ori Z: "Benjamin Levy: Kingdom of Paradox," *Sunstorm Fine Art*, pp. 52-53, illustrations, summer 1993.

_____: "Twee soorten humor bij Levy en Topor," *Kunst kijken*, Amsterdam, Holland, December 1975.

Van Garrel, Betty: "Benjamin Levy," *Handelblad/NRC*, illustration, Amsterdam, Holland, March 10, 1978.

Van Straten, Hans: "Benjamin Levy: A World of Dream and Humour," *Utrechts Niewsblad*, Utrecht, Holland, January 27, 1978.

Visser, Mathilde: "Benjamin Levy," *Financial Dagblad*, Kunstkroniek, Amsterdam, Holland, December 12, 1975.

Waterschoot, H.,"Benjamin Levy als buitenbeen," *Plastiche kunst*, February 15, 1978.

Welzenbach, Michael: " 'Portraits' Personal and Perplexing," *The Washington Times*, illustration, Washington, D.C., October 24, 1985.

White, Wallace: "El Museo Vial 'Rafael Bogarin' enVenezuela," *Geo Mundo*, pp. 165-175, illustration, Venezuela, February 1983.

Wingen, Ed: "Benjamin Levy 'n geboren verteller", *Telegraaf*, Amsterdam, Holland, March 16, 1978.

EXHIBITION CATALOGS AND BOOKS

_____: *A Collector's Eye: The Olga Hirshhorn Collection*, Smithsonian Institution , Washington, D.C., 1981.

_____: *Art en la Carratera*, Museo Vial, Venezuela, 1982.

Aviram, Batya. *Shalom Haver: 30 Artistic Responses to the Life and Tragic Death of Yitzhak Rabin*, Project Judaica Foundation, Washington, D.C., 1997.

Bilski, Emily D.: *Golem: Danger, Deliverance and Art,* The Jewish Museum, New York, New York, 1988.

Boulakia, Fabien: *Group Exhibition at Foire Internationale d'Art Contemporain*, Paris, France, 1984.

Eitan, Rachel: *Benjamin Levy*, Miami Museum of Modern Art, 1971.

Eitan, Rachel: *Benjamin Levy*, Galerie T., Amsterdam, Holland, 1975.

Kotte, William: *Prentenboek*, Bureau Culturele Zaken van de Gemeente Utrecht Hedendaagse Kunst, Utrecht, Holland, 1972.

Kotte, William: *Exhibition catalog*, Hedendaagse Kunst, Utrecht, Holland, 1978.

_____: *Group exhibition catalog*, Tel Aviv Museum of Art, Tel Aviv, Israel, 1973.

Mertins, Phil, and Vroman, Leo: *Benjamin Levy,* Galerie S65, Aalst, Belgium, and Wetering Galerie, Amsterdam, Holland, 1973.

Van Tright, Jan. *Kinderen kijken u ann*, Amsterdam, Holland, 1979.

Verber, Eugen: "Sefarad: To Spain and Back," Prague, Czechoslovakia, 1992.

Soltes, Ori Z. "The Travels of Benjamin and 'La Familia', B'nai B'rith Klutznick National Jewish Museum, Washington, D.C., 1993.